T0294218

LEITH
REFLECTIONS

Jack Gillon & Fraser Parkinson

AMBERLEY

First published 2021

Amberley Publishing
The Hill, Stroud, Gloucestershire, GL5 4EP
www.amberley-books.com

Copyright © Jack Gillon & Fraser Parkinson, 2021

The right of Jack Gillon & Fraser Parkinson to be
identified as the Authors of this work has been asserted
in accordance with the Copyrights, Designs and Patents
Act 1988.

ISBN 978 1 3981 0416 7 (print)
ISBN 978 1 3981 0417 4 (ebook)

British Library Cataloguing in Publication Data.
A catalogue record for this book is available from the
British Library.

Typesetting by SJmagic DESIGN SERVICES, India.
Printed in Great Britain.

Introduction

Leith was first established on the banks of the Water of Leith, at the point where the river entered the Firth of Forth. The first historical reference to the town of Leith dates from 1140, when the harbour and fishing rights were granted to Holyrood Abbey by David I. The early settlement was centred on the area bounded by the Shore, Water Street, Tolbooth Wynd and Broad Wynd.

Leith became Edinburgh's port in 1329 when King Robert I granted control of the town to the Burgh of Edinburgh. Further royal charters during the fifteenth century gave Edinburgh the rights to land adjoining the river and prohibited all trade and commercial activity by Leithers on the ground owned by Edinburgh.

Leith constantly features in the power struggles that took place in Scotland and the battles, landings and sieges of Leith have had an influence on its development. It was attacked by the Earl of Hertford in 1544 during the Rough Wooing – his mission was to arrange a marriage between the young Mary, Queen of Scots and her English cousin, later Edward VI. Three years later, Leith was pillaged after the defeat of the Scottish army at the Battle of Pinkie. Immediately following this, Mary of Guise, the Roman Catholic Regent of Scotland, moved the seat of government to Leith and the town was fortified.

In the second half of the eighteenth century regular streets, including Bernard Street and Constitution Street, were built on the edges of the town and Queen Charlotte Street was cut through the medieval layout. Leith became a fashionable seaside resort which, as early as 1767, included a golf clubhouse built by the Honourable Company of Edinburgh Golfers at the west end of the Leith Links.

Leith expanded significantly during the nineteenth century, associated with railway building and the growth of the docks. Port-related industries and warehousing also grew rapidly during this period. This contemporary description paints a vivid portrait of the Port at the time – 'Leith possesses many productive establishments, such as ship-building and sail-cloth manufactories ... manufactories of glass ... a corn-mill ... many warehouses for wines and spirits ... and there are also other manufacturing establishments for cordage, brewing, distilling, and rectifying spirits, refining sugar, preserving tinned meats, soap and candle manufactories, with several extensive cooperages, iron-foundries, flourmills, tanneries and saw-mills.'

In 1833, Leith was established as an independent Municipal and Parliamentary Burgh with full powers of local government. Leith expanded as massive warehouses and additional docks were built: the Victoria Dock in 1851, the Albert Dock in 1881 and the Imperial Dock in 1903.

After the passing of the Leith Improvement Act in 1880, many of the slums and most of the earlier buildings were cleared away. This coincided with programmes of major tenement development – in particular the building of dense tenement blocks over the fields between Leith Walk and Easter Road.

In 1920, the town was amalgamated with Edinburgh. By the time of the amalgamation, Leith contained its successful port, significant industrial enterprises, shipbuilding yards, warehouses, bonds and a population densely packed into ageing tenements and housing stock.

Following the First World War, the number of shipyards was reduced to one, and the stream of pre-war trade dwindled. Through the interwar years, Leith had high unemployment. However, the population of Leith was still around 80,000 at the start of the Second World War.

The 1950s brought the final days of what older Leithers would describe as the heart of Leith. The brimming tenements, shops and small workshops along the old and ancient thoroughfares in the heart of Leith were destined for redevelopment. The Kirkgate, St Andrew Street, Tollbooth Wynd, Bridge Street and many more would disappear in the coming decade.

After decades of industrial decline, slum clearance and depopulation in the post-war era, Leith gradually began to enjoy an upturn in fortunes in the late 1980s. The emphasis moved to urban renewal, community needs and the conservation of Leith's historic buildings.

The town retains a passionate sense of individuality and its people a proud sense of identity. Today, Leith is a thriving port and cruise line destination with many excellent hotels, restaurants and bars. It is also the base of the Royal Yacht Britannia and the home of Scotland's Civil Service at Victoria Quay.

Leith Reflections incorporates material from our earlier book, *Leith Through Time* (2014). The blending of the images in *Leith Reflections* serves to highlight the radical changes that have reshaped Leith over the years.

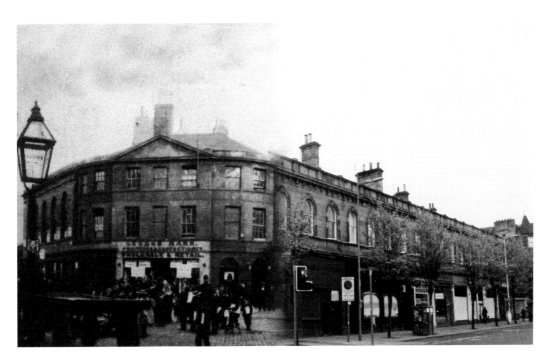

Foot of Leith Walk

The older image shows a busy scene at the Foot of Leith Walk. The premises of George Marr, fruiterer and confectioner, are prominent on the corner of Leith Walk and Duke Street. The earlier buildings at the Foot of the Walk were replaced by Leith Central railway station which opened on 1 July 1903.

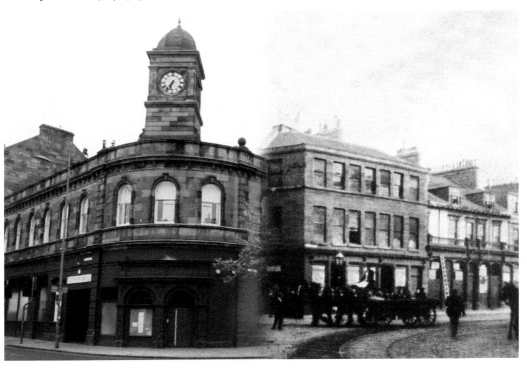

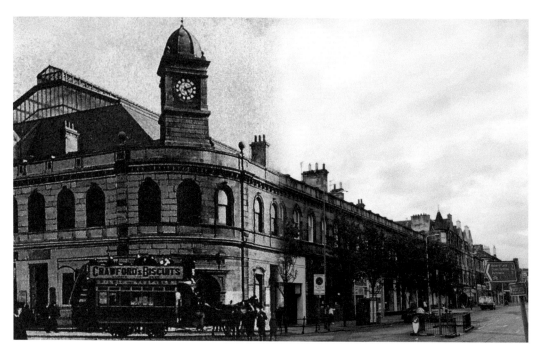

Leith Central Station

Leith Central was the terminal station of the Leith branch of the North British Railway. The train trip from Waverley to Leith Central took four and a half minutes and was known as the *Penny Jump*. The station took up a complete town block running all the way through from Leith Walk to Easter Road, most of which was covered by a huge steel-framed roof. The four platforms were 15 feet above street level.

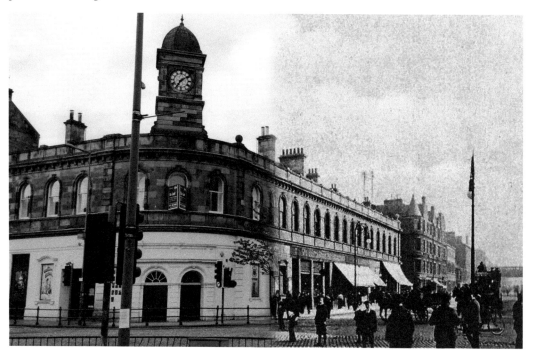

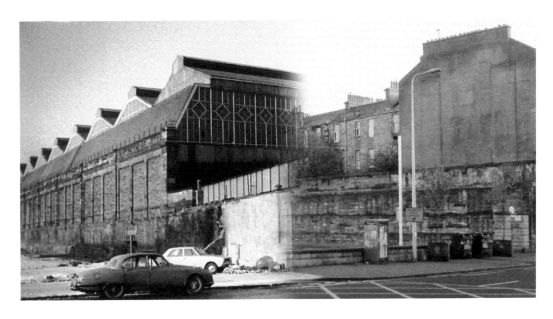

Leith Central Station
The older image shows the remnants of the bridge that once spanned Easter Road and was the sole entrance and exit for all rail traffic. Leith Central station closed to passenger traffic on 7 April 1952 and continued to be used as a diesel maintenance depot until 1972 before closing. In its finals years the derelict station was much used by drug users and the inspiration for the ironic title of Irvine Welsh's book *Trainspotting.*

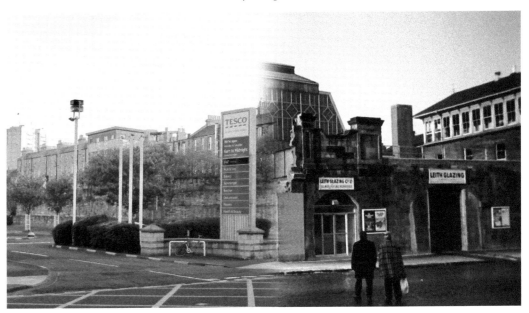

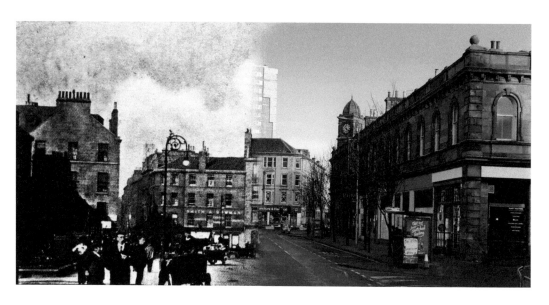

The Foot of Leith Walk

The Foot of Leith Walk was still almost entirely rural in 1785. Scattered development on both sides of Leith Walk followed in the late eighteenth century and early nineteenth century.

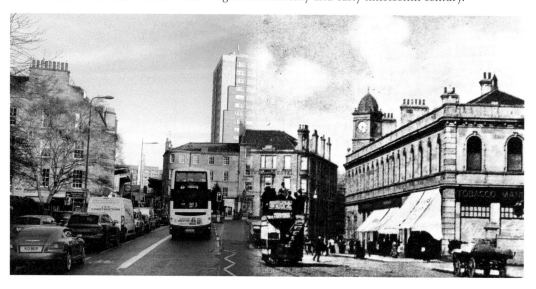

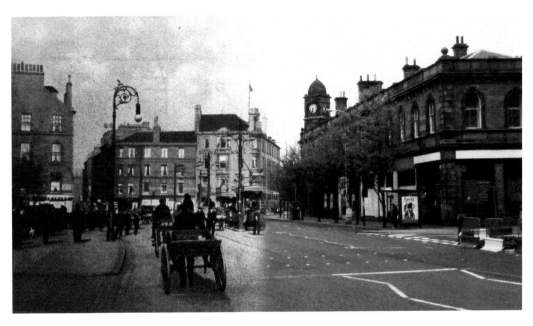

The Foot of Leith Walk

The eighteen-storey high rise Kirkgate House, dating from the 1960s, is prominent in the new image. The well-known 'Central Bar' was incorporated into the structure of the station.

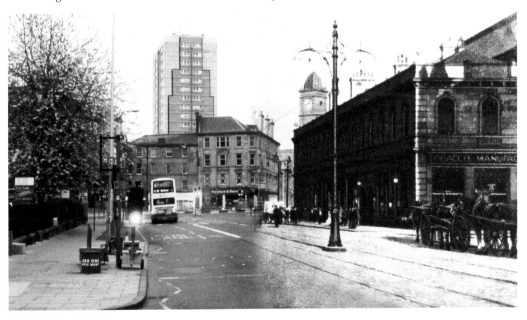

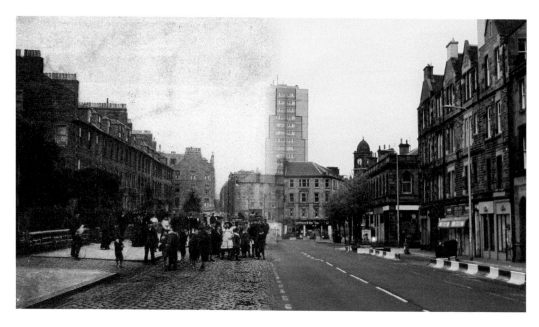

The Foot of Leith Walk
A tram heading for the Dock Gate seems to have attracted a crowd of young and old Leithers in the older image. Some of the youngsters are barefoot.

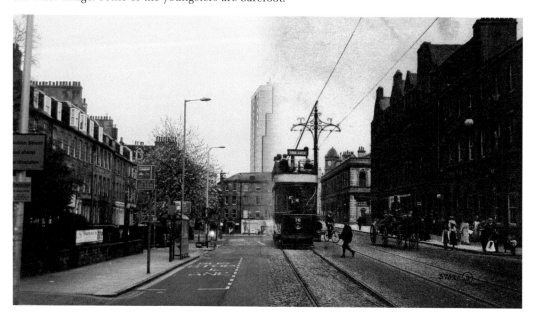

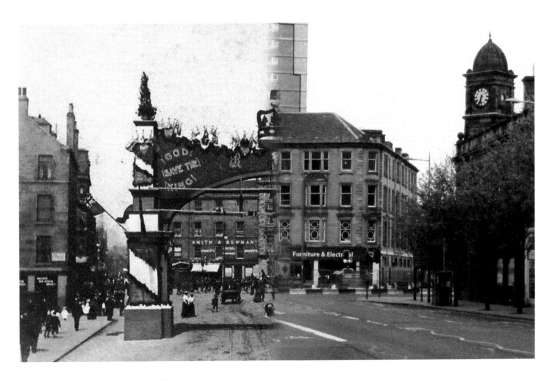

The Foot of Leith Walk
The older image shows an elaborate arch erected at the Foot of the Walk to commemorate the coronation of Edward VII in 1902.

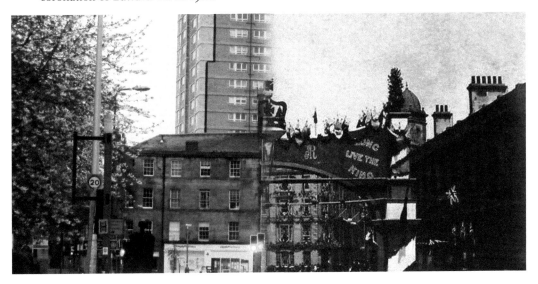

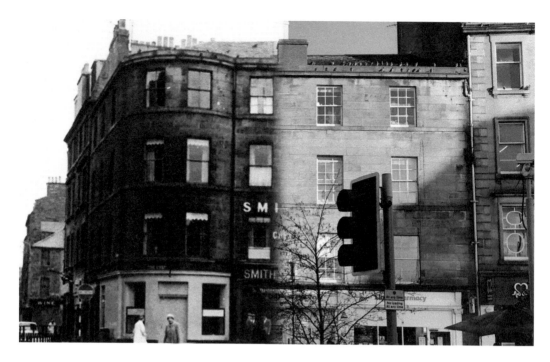

The Foot of Leith Walk

The Smith and Bowman Chemist's shop was a familiar feature of the Foot of Leith Walk for decades. The statue of Queen Victoria in the older image is one of Leith's best-known landmarks. The statue was unveiled in front of a crowd of 20,000 people on 12 October 1907. Over the years many Leithers have gathered under the watchful eye of the Queen. The statue was moved in 1968 and again in 2002.

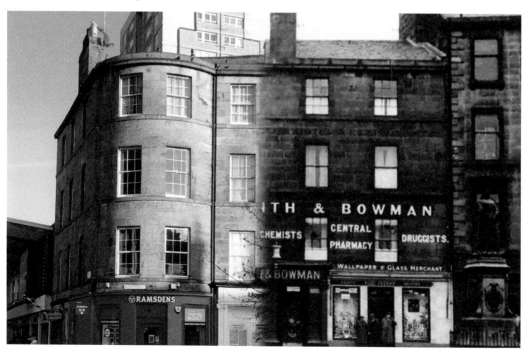

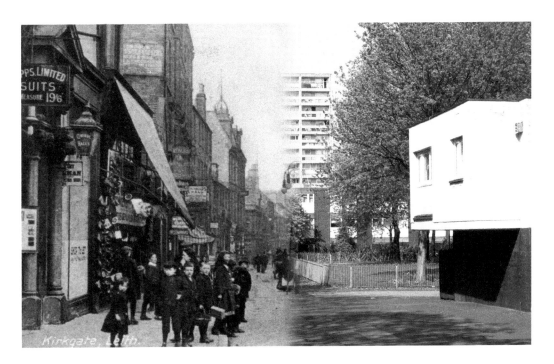

The Kirkgate

The Kirkgate was the pulsating heart of Leith. It was one of the oldest and principal streets of Leith until the 1960s when progress made its mark and replaced the entire area with modern housing developments, the New Kirkgate shopping centre and a community centre. All that remains of the historic location is Trinity House and South Leith Parish Church. The ornamental street lamps in the older image mark the entrance to the New Gaiety Theatre, which was opened in 1889 as the Princess Theatre, and finally closed in 1956.

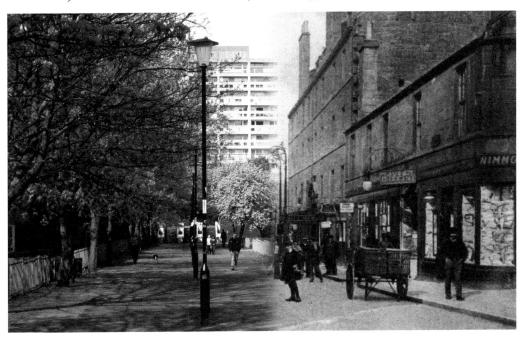

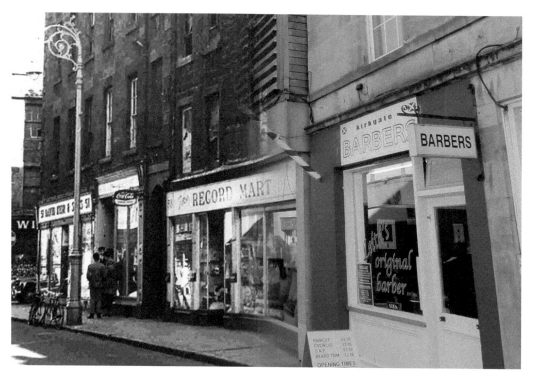

The Kirkgate

Some of the familiar shops at the top of the Kirkgate from the 1950s and 1960s in the older image. A group of Teddy Boys congregate outside of the Albert Fish Restaurant next to the popular Record Mart.

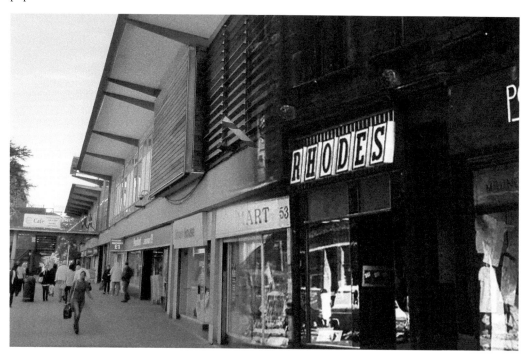

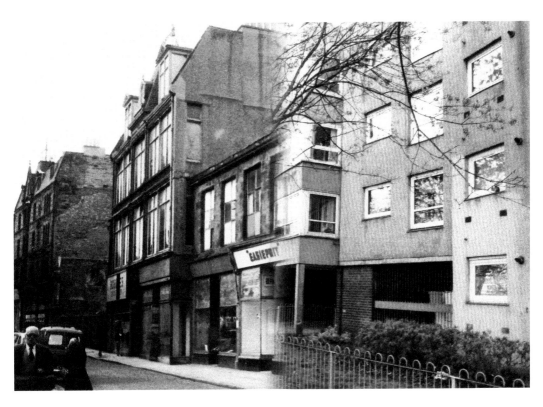

The Kirkgate
Views along the Kirkgate towards the Foot of Leith Walk from the corner of Coatfield Lane.

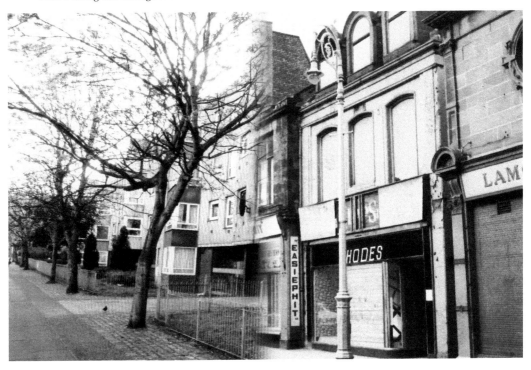

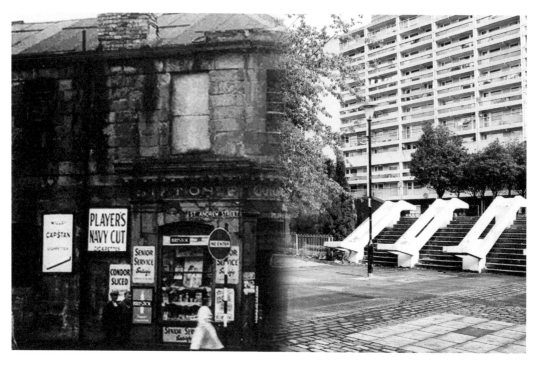

The Kirkgate

An array of cigarette adverts on McLaggan's Newsagent shop at the corner of St Andrew Street and the Kirkgate in the older image. This newsagent was a well-known stopping-off point for papers and fags.

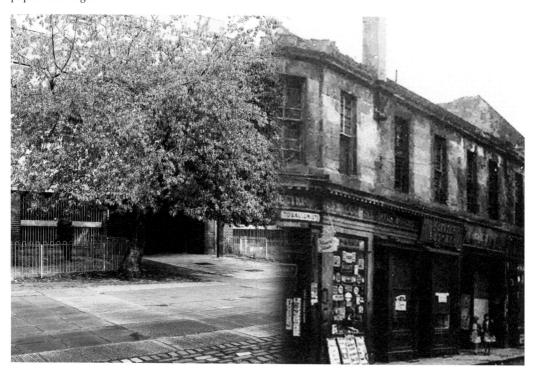

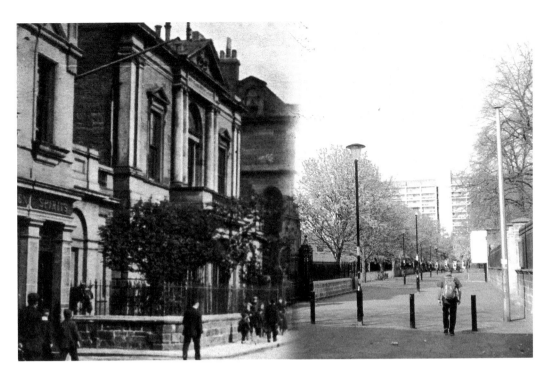

Trinity House, The Kirkgate

Trinity House was built on the Kirkgate between 1816 and 1818 as the headquarters of the Fraternity of Masters and Mariners, a charitable foundation for seamen. The current building incorporated the basement and vaults of the former Trinity House and Mariners' Hospital of 1555. The Fraternity's original purpose was benevolent, but later it provided pilots for the navigation of the Forth, and was responsible for installing the first oil lamp guide light on May Island.

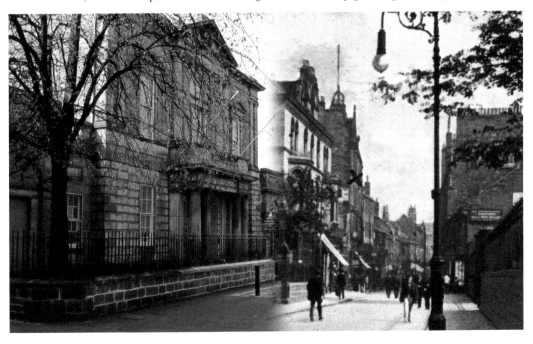

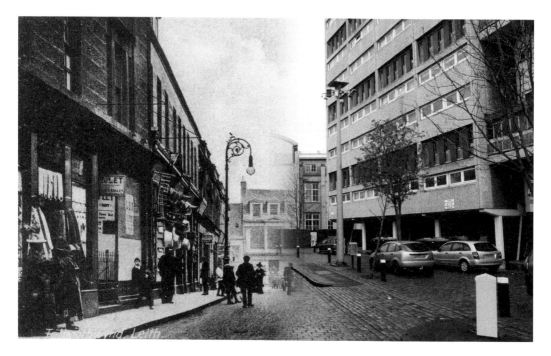

Tolbooth Wynd

Tolbooth Wynd was one of the oldest streets in Leith and takes its name from the long-gone original Leith Tolbooth which dated from 1565. Tolbooth Wynd, like the Kirkgate, was noted for its bustling character and wide range of shops. Tolbooth Wynd disappeared with the Kirkgate in the comprehensive redevelopment of the sixties. A number of the lamp standards in the older photograph can be found around Leith today.

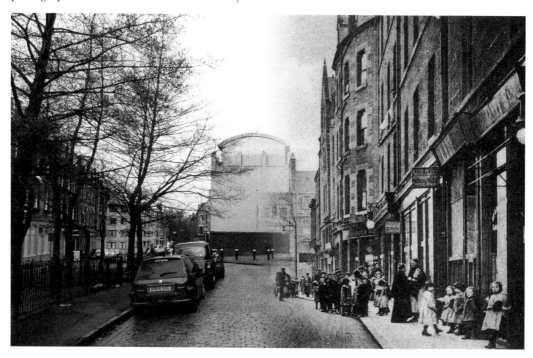

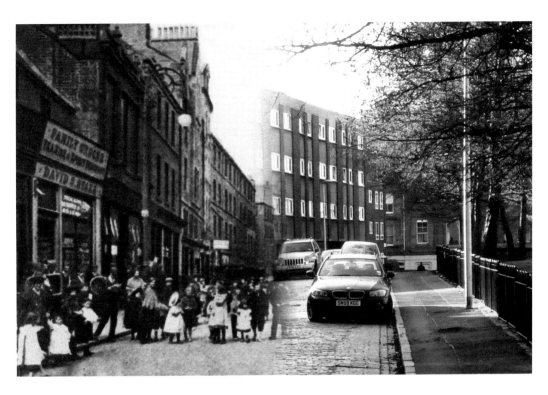

Tolbooth Wynd

Looking towards the Shore on Tolbooth Wynd. A large group of Leithers gather to ensure their place in the older image. Little did they realise at that time their place in history through this image.

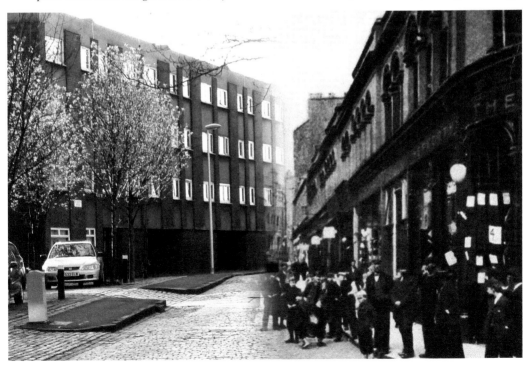

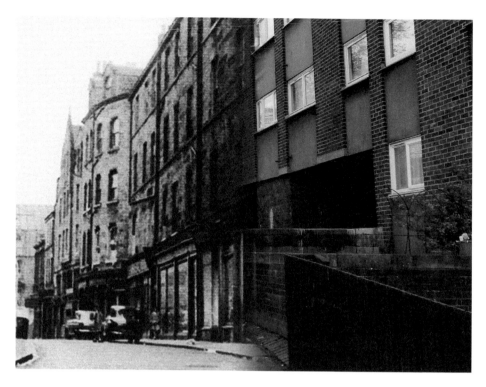

Tolbooth Wynd

The historic stone tenements of Tolbooth Wynd were replaced by the multi-storey Linksview House and other new housing in the 1960s. The small roadway on the right edge was called Market Street.

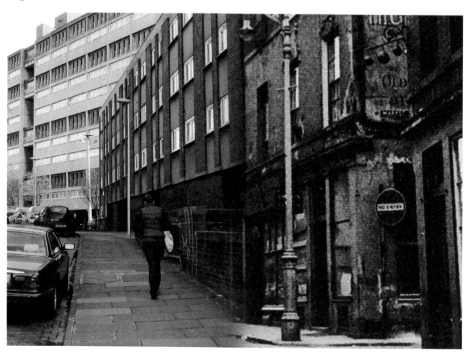

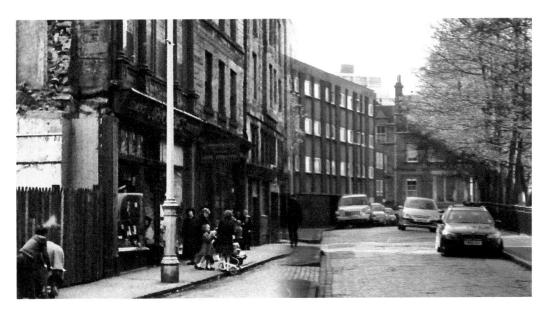

Tolbooth Wynd

The older image shows Tolbooth Wynd from the junction with the Kirkgate. The demolished building on the left of the older image is a portent of things to come for this part of Leith.

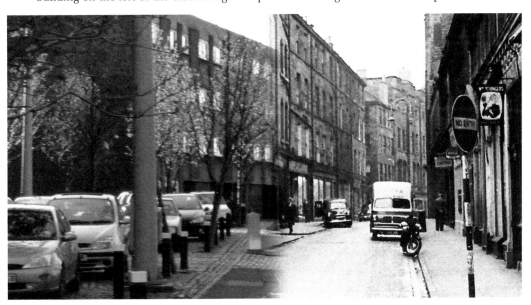

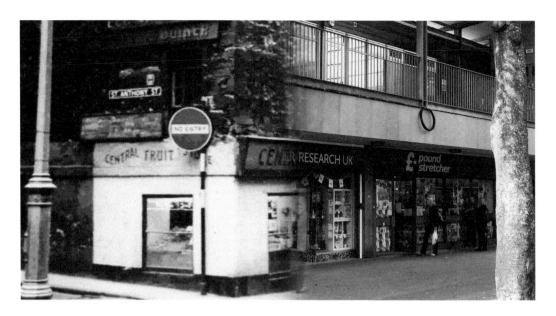

St Anthony Street/Kirkgate

St Anthony Street was one of the Kirkgate's well-known side streets. It took its name from the preceptory of the friars of St Anthony which was founded in 1418. Much of the street was lost as part of the new Kirkgate development in the 1960s.

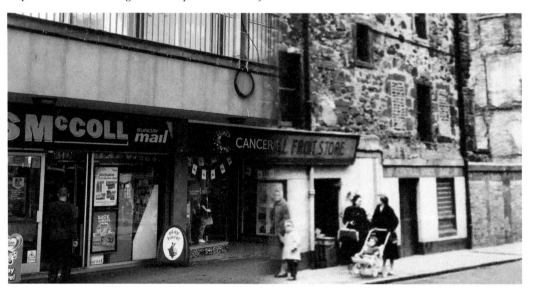

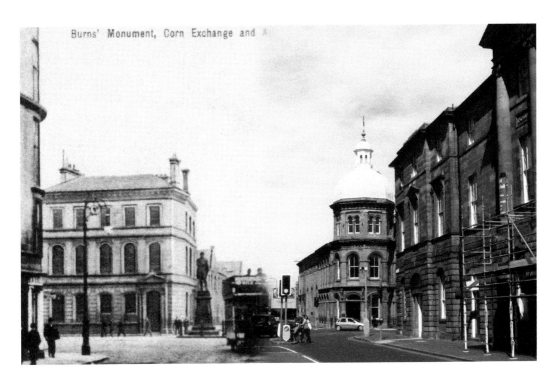

Assembly Rooms, Constitution Street

The Assembly Rooms opened in 1783 as a centre for social events for more affluent Leithers. The adjoining Exchange Buildings were added in 1809 at a cost of £16,000 and were the commercial base of the port of Leith. The Corn Exchange building in the background was at one time the hub of the trading of grain in Scotland. The building dates to 1862 and includes a distinctive frieze which shows cherubs involved in a range of activities associated with the production and marketing of grain.

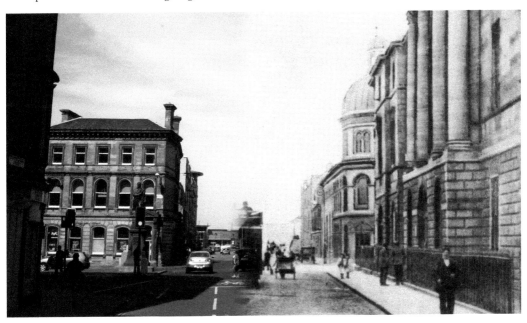

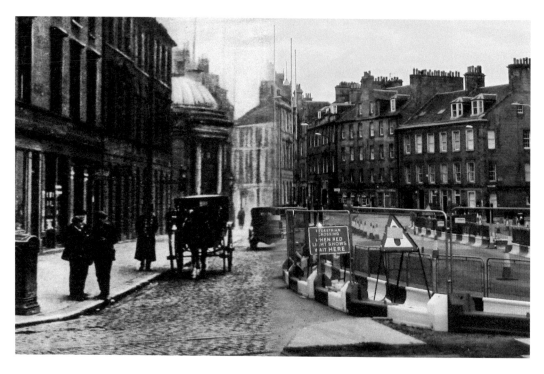

Bernard Street

Bernard Street is the civic heart of Leith and an outstanding urban space. The street takes its name from Bernard Lindsay, who, in 1604, held the title Groom of the Bedchamber to James VI. The recent image shows work underway for the Edinburgh Tram Line.

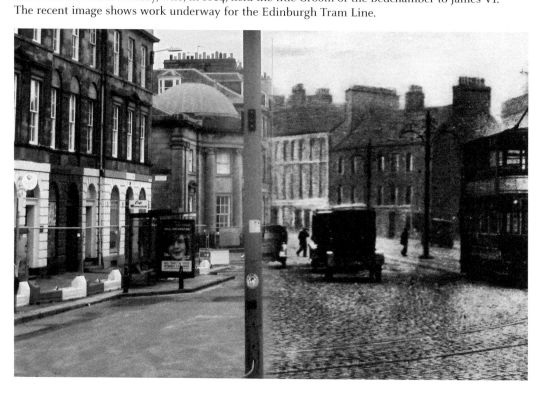

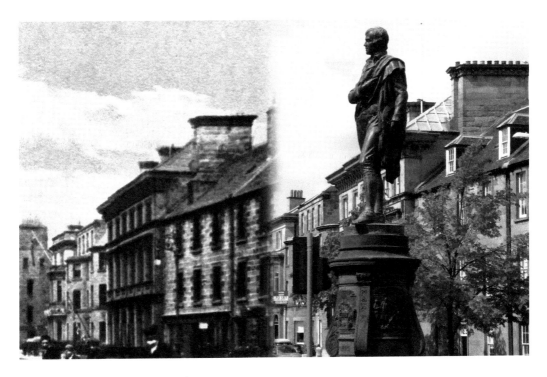

Burns' Monument, Bernard Street

It was reported that a 'holiday mood' prevailed as thousands gathered on Bernard Street on 15 October 1898 for the unveiling of a new bronze statue of Robert Burns. The pedestal includes bronze panels depicting poems by Burns. The statue is by the eminent sculptor D. W. Stephenson.

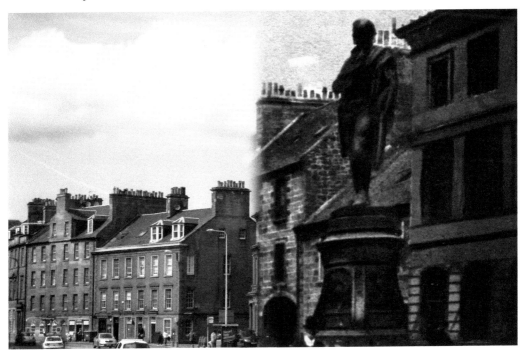

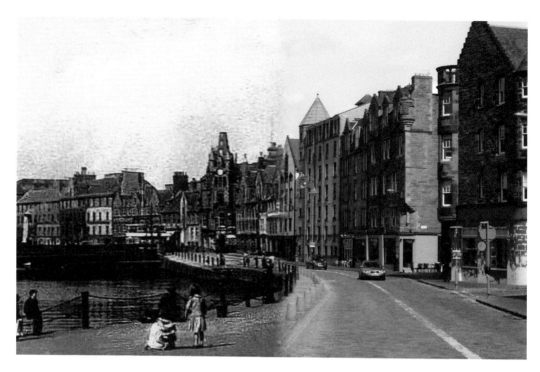

The Shore

The Shore is not on the seashore, but forms a curving street which leads into the entrance to the docks. It is the most historically important part of Leith. Mary, Queen of Scots made landfall from France at the Shore in 1561 and the arrival of King George IV on his state visit is marked by a plaque on the quayside.

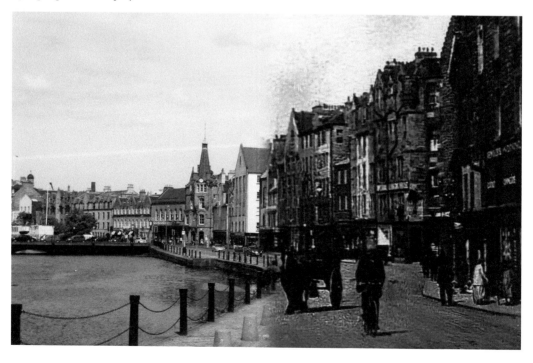

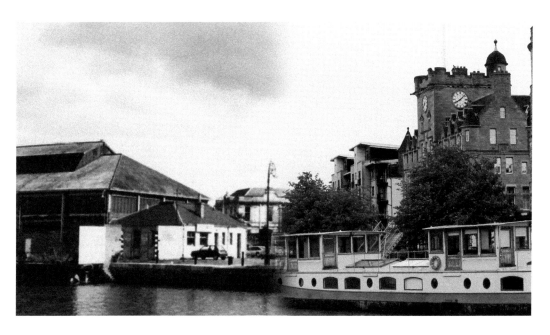

The Shore
The older image shows the Shore area in 1988, at the start of its regeneration which attracted a broad range of new upmarket bars, restaurants and new housing. (Older image courtesy of Jennifer Wells)

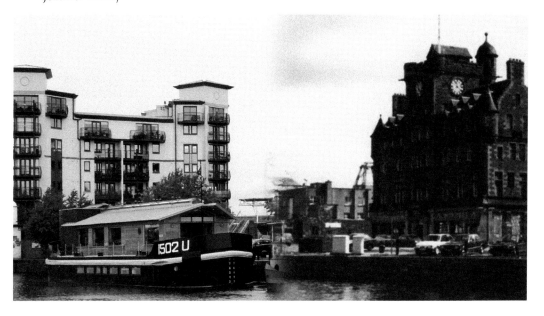

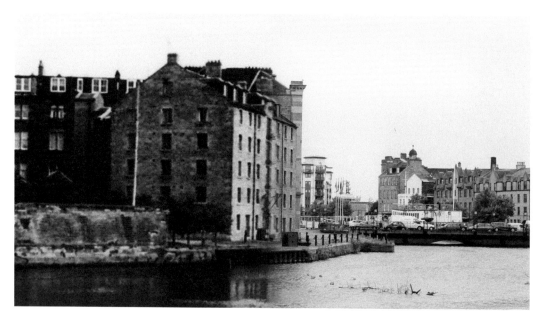

Ronaldson's Wharf, The Shore
Ronaldson's Wharf changed from commercial use in the 1980s to its current residential use.
(Older image courtesy of Jennifer Wells)

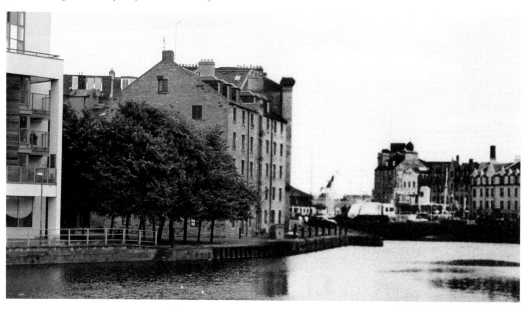

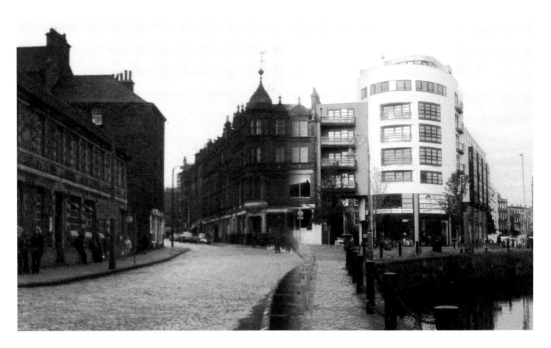

The Shore
The recent addition of a modern block of flats makes a dramatic impact on the upper Shore.

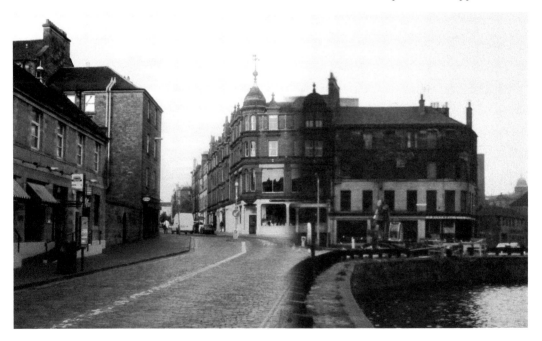

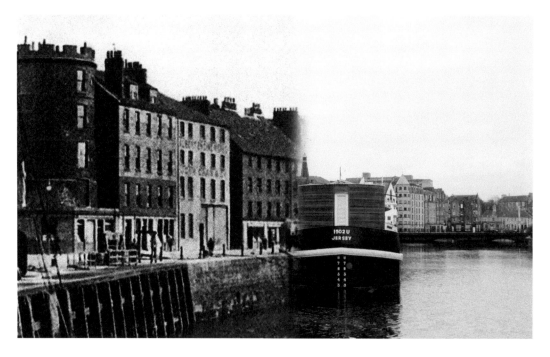

The Shore

A panorama of the Shore from the harbour. The Signal Tower, at the corner of the Shore and Tower Street, is prominent in the foreground of the images. The Signal Tower dates from the seventeenth century and was built originally as a windmill. In 1805, the sails were removed and battlements added. It was used as a signal tower from which flags were displayed to let ships entering the harbour know the depth of water at the harbour bar.

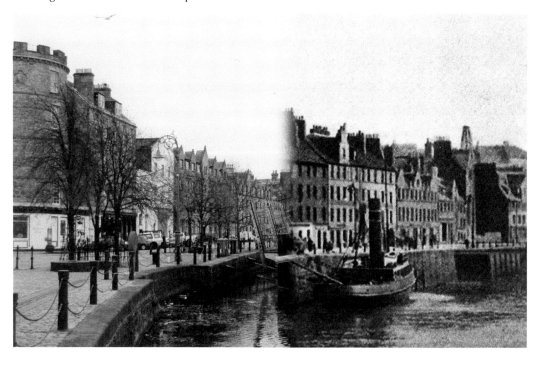

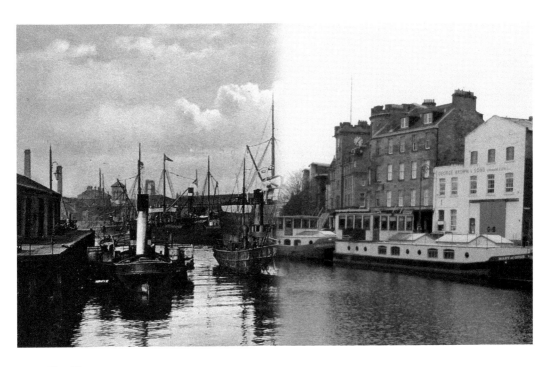

The Shore

The array of boats in the older image reflects how bustling the Shore area was in its heyday. Leith's trading history goes back hundreds of years.

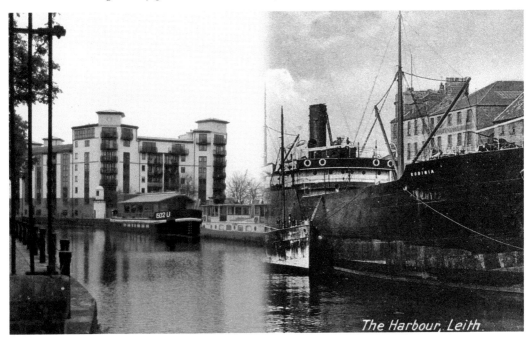

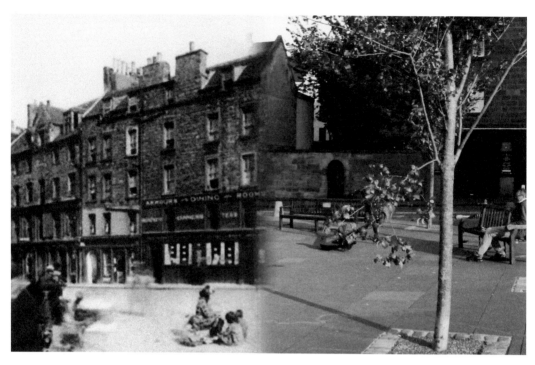

The Shore

Some Leith kids enjoy a game on the Shore with Armour's Dining Rooms in the background in the older image. These images highlight the significant changes on the Shore over the years.

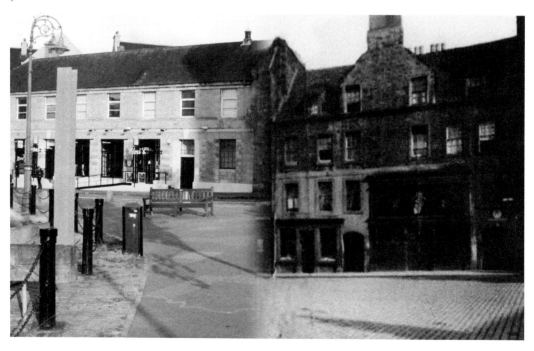

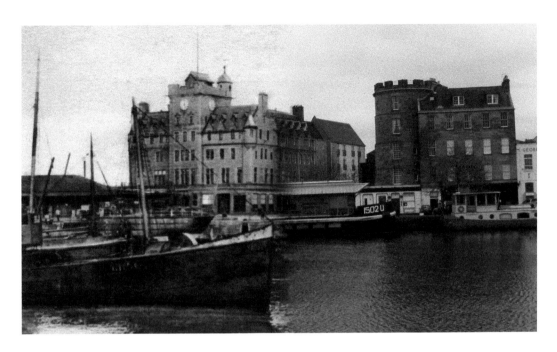

Sailors' Home, The Shore

The Sailors' Home was opened on 29 January 1885 by Lord Roseberry. It provided a dry warm bed for sailors visiting Leith from around the globe. The massive square 23-metre (75-foot) high tower with a large clock dial was the main feature of the frontage. The building was converted into the Malmaison Hotel in 1994.

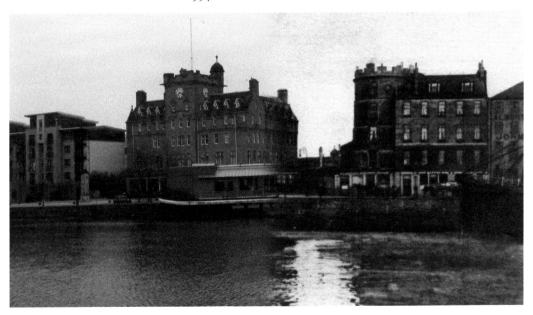

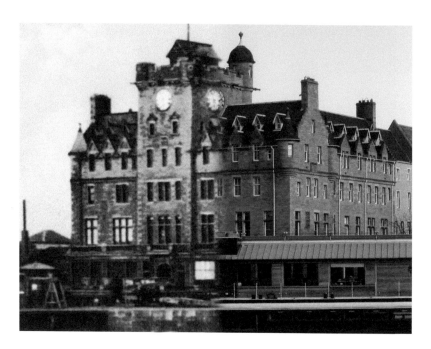

Sailors' Home, The Shore

The accommodation in the Sailors' Home included a restaurant, a 'coffee-palace', a recreation hall, storage for the sailors' equipment, a wash-house, and a laundry on the ground floor. There was an officers' mess; a library; smoking room; reading room and dining room, which could accommodate a hundred, on the first floor. The upper floors included a shop which provided 'all that was needed for Jack ashore' and sleeping compartments for fifty-six sailors and nine officers.

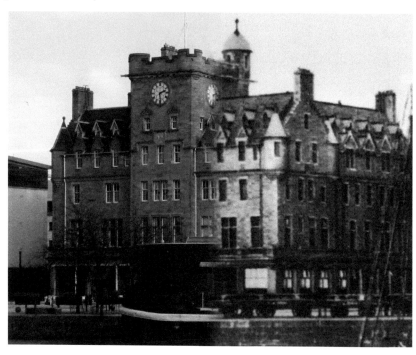

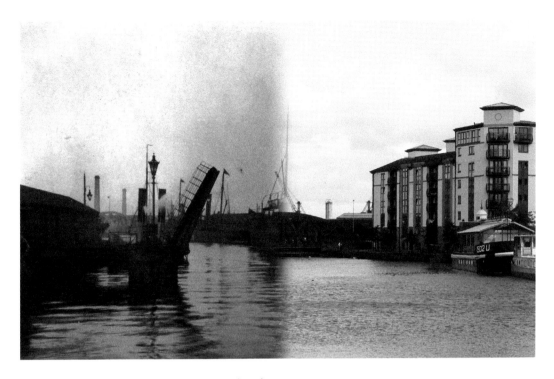

The North British Railway Bridge, The Shore

The Lower Drawbridge was a crossing from the rear of the Custom House to the Shore and was removed in March 1910. This bridge is often mistaken for the drawbridge that directly connected Bernard Street with Commercial Street, which was replaced and is today a main traffic route. (Older image courtesy of Archie Foley)

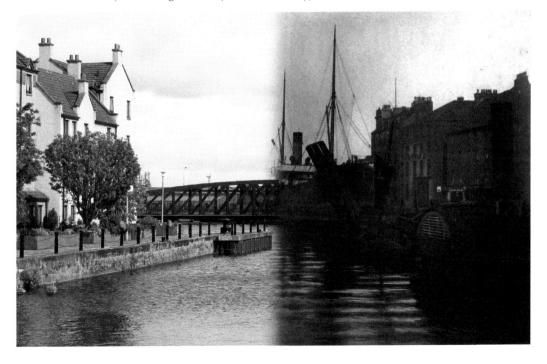

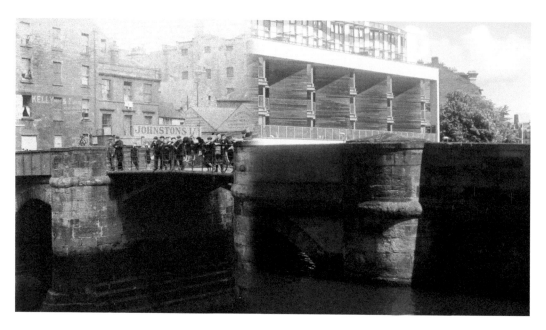

The Upper Drawbridge, The Shore

This bridge replaced the nearby fifteenth-century Brig o' Leith crossing in 1787. It enabled ships to berth further upstream. The tenements in the background of the older image have been replaced by a recent development of flats. (Older image courtesy of Archie Foley)

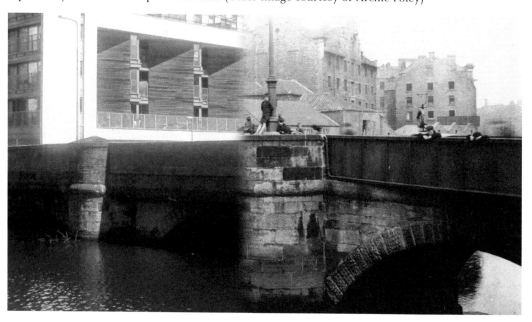

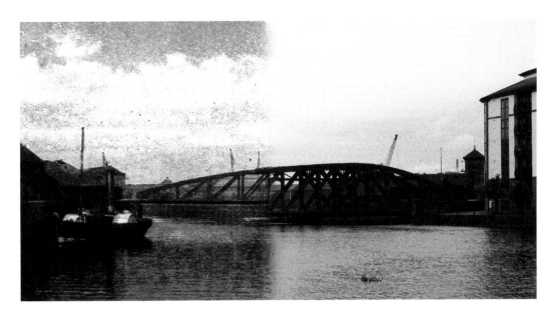

The Victoria Swing Bridge

The Victoria Swing Bridge was opened in 1874 to link the Victoria Dock with the Albert and Edinburgh Docks. It was the largest swing bridge in the United Kingdom until the opening of Kincardine Bridge in 1937. The bridge was hydraulically operated to allow ships to pass up the Water of Leith. A new fixed road bridge has been built immediately downstream of the old to link motor traffic through to the Ocean Terminal shopping centre.

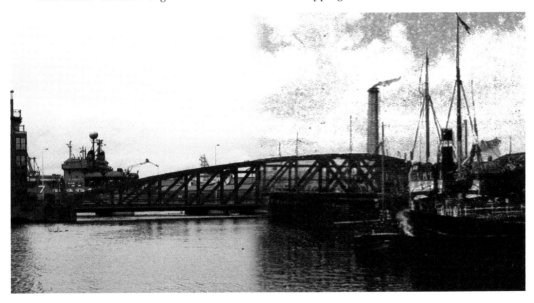

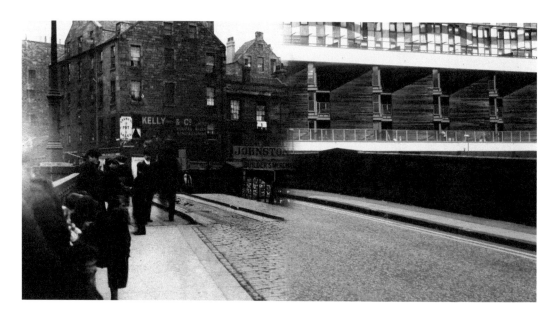

The Upper Drawbridge, The Shore

A group of Leithers on the Upper Drawbridge in 1909 in the older image. This is the bridge that connects Tolbooth Wynd and what was originally known as Bridge Street, present-day Sandport Place. The Upper Drawbridge dates to 1788. The same bridge still stands today but the centre was reconstructed and the opening mechanism removed. (Older image courtesy of Archie Foley)

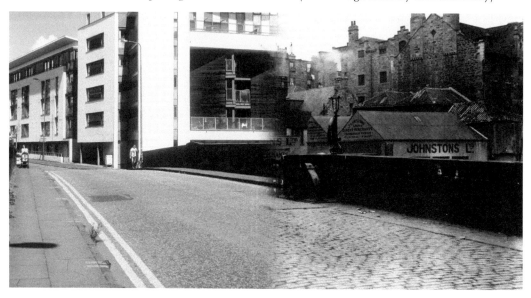

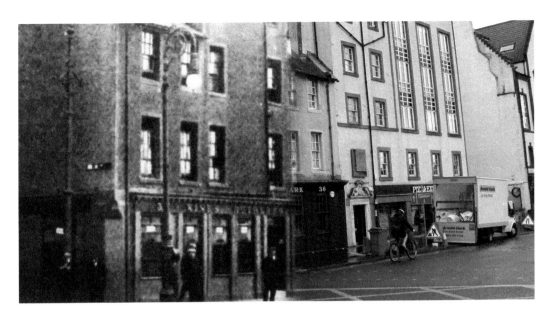

The King's Wark, Bernard Street and The Shore

The King's Wark has characteristic Dutch gables and scrolled skewputts in typical early eighteenth-century fashion. It stands on older foundations which were part of a much larger complex of buildings begun by James I in 1434 to serve as a royal residence with a store-house, armoury, chapel, and tennis court.

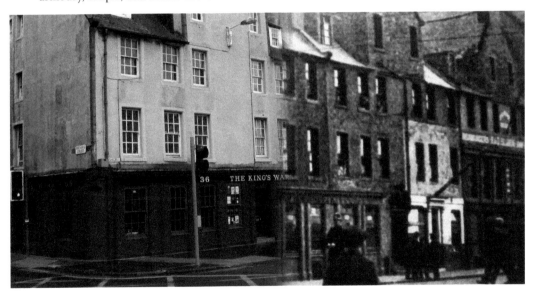

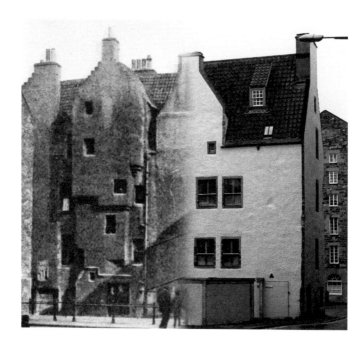

Andro Lamb's House, Water Lane

Lamb's House is one of the largest and most architecturally impressive seventeenth-century merchants' houses in Scotland. The house takes its name from Andrew Lamb, the first recorded owner. In the early twentieth century the building was subdivided into a number of flats and by the 1930s was in a derelict condition. The Marquess of Bute stepped in to buy the building for £200 in 1938. It was restored by the architect Robert Hurd and in 1958 the building was gifted to the National Trust for Scotland. It was then leased to the Edinburgh and Leith Old People's Welfare Council and used as a day centre for the elderly. It has now been restored as a family home.

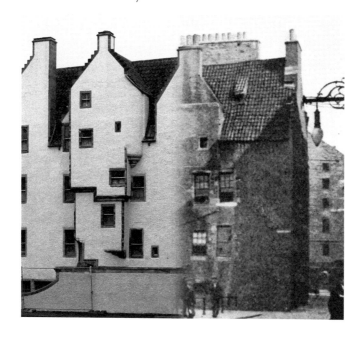

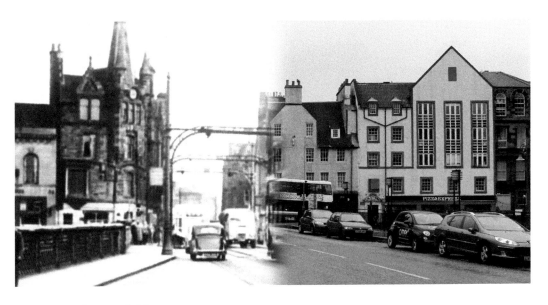

Bernard Street Bridge

The large hoop-like structures in the older image carried the electric tram cables so that the bridge could still open for ships. The swing bridge was replaced by a fixed structure in the 1960s.

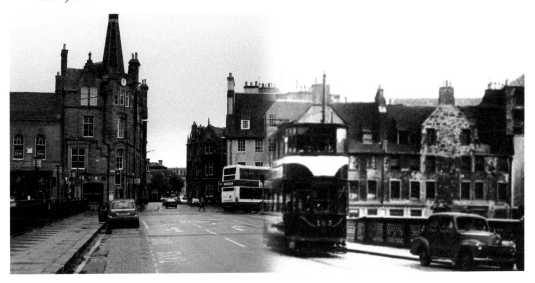

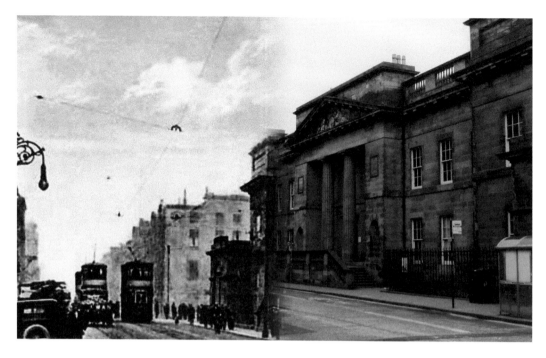

Customs House, Commercial Street

The Customs House in Commercial Street was designed by Robert Reid and opened for the business of collecting duty on goods imported through Leith in 1812. Its Greek Doric Revival style is typical of the way Leith buildings reflected those of the neoclassical New Town of Edinburgh. It is located on the site of the old ballast quay and was a replacement for the old Customs House in Tolbooth Wynd. The pediment above the entrance displays the royal coat of arms of George III.

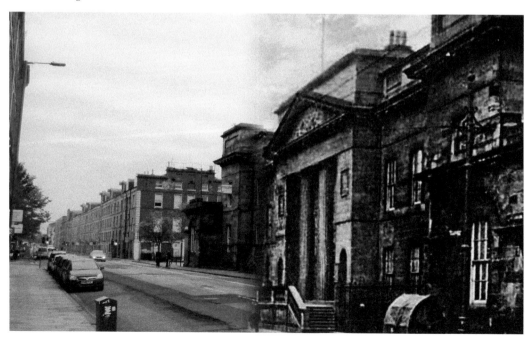

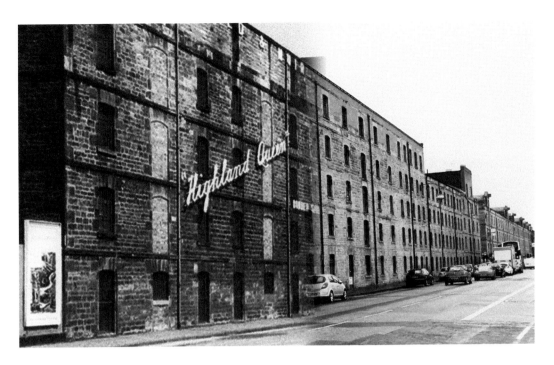

Highland Queen, Commercial Street

The older image shows the Highland Queen (MacDonald & Muir) whisky bonds, which have been converted to upmarket flats, restaurants and shops. Leith has a long association with whisky. Scores of bonded warehouses in Leith matured 90 per cent of all the whisky made in Scotland and the Vat 69 blend was distilled locally by Sandersons. (Older image courtesy of Steven Saunders)

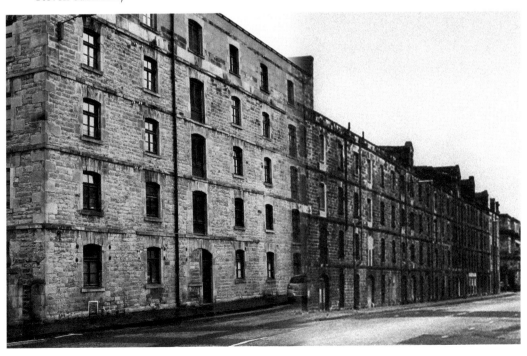

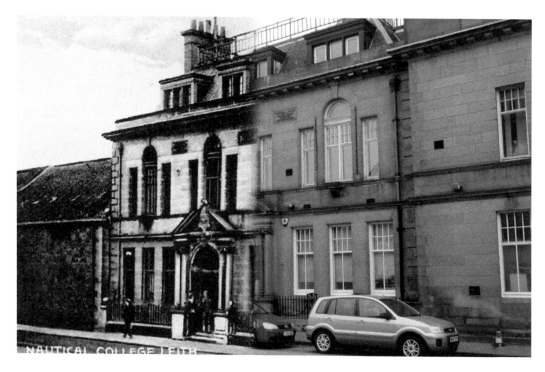

Leith Nautical College, Commercial Street

Leith Nautical College was originally founded as Leith Navigation School in 1855 at the Mariners' Church in Commercial Street. In 1903, the school moved to purpose-built premises in Commercial Street and changed its name to Leith Nautical College. The Commercial Street college closed in 1977 and moved to new premises in Milton Road. Many Leith seamen will have fond memories of their training days at the college.

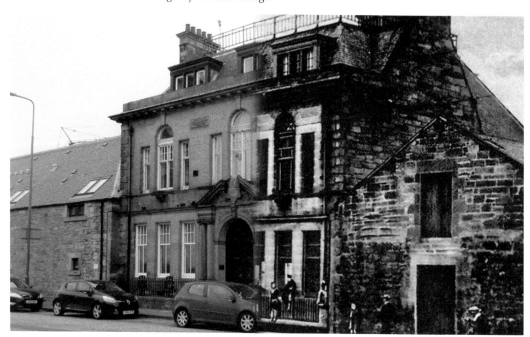

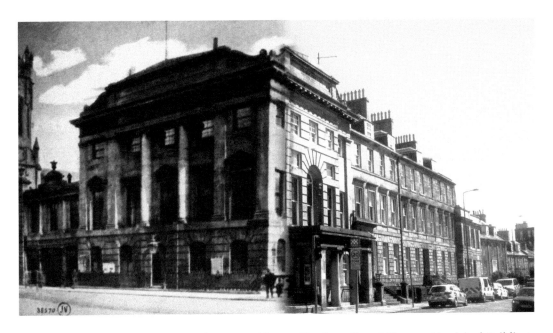

Leith Police Station, Constitution Street/Queen Charlotte Street (former Municipal Buildings and Council Chambers)

In 1833, when Leith won its independence from Edinburgh's control and became a separate burgh, the new council took over the existing court building which had been built five years before. The building was an important symbol of Leith's independence. Leith's architecture of the time reflected the Port's heightened aspirations and a number of substantial buildings appropriate to its new status were built throughout the nineteenth century. The Leith Police office has been based in the building throughout its history.

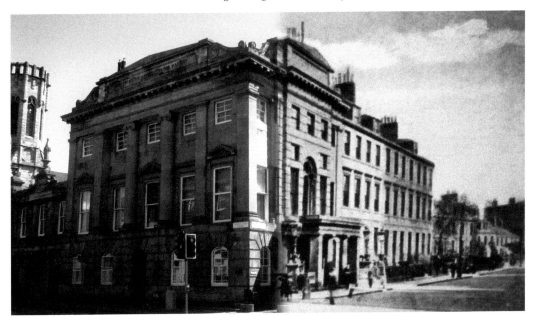

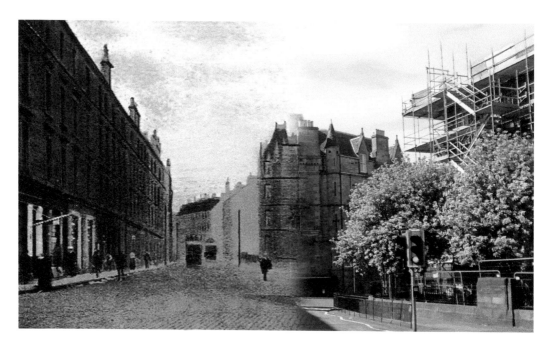

Duke Street

Duke Street was named after the Duke of Dalkeith in 1812. He was an enthusiastic golfer and rented a house in the area to be close to the course at Leith Links. Incredibly only the immediate right side of this view has changed over the years. The tenements of Duke Street remain today having survived the redevelopment of the 1960s. This view is from the junction at the foot of Easter Road. Duncan Place is down to the right behind the small brick building in the older image, which was a tram/bus turnaround shelter for crew to have tea break.

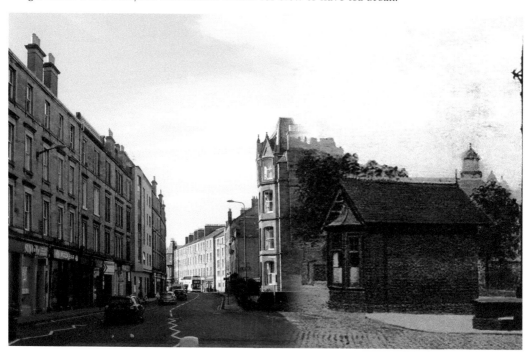

Duke Street Shops

The older image shows the Duke Street entrance to the former Palace Cinema in 1992, when it had become Cuemasters Snooker Hall. The building was originally the Palace Cinema, which opened in 1913 and seated around 2,000. It closed in 1966 and was turned into a bingo hall. It is now part of a large pub chain. Remnants of the original cinema can be seen in the upper part of the building. (Older image courtesy of Steven Saunders)

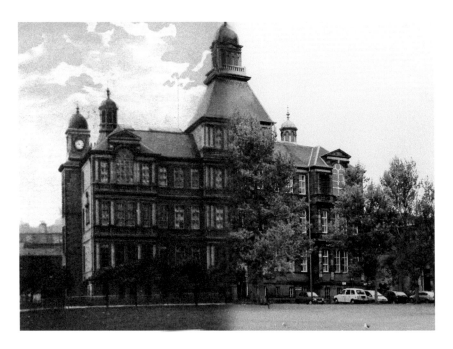

Leith Academy, St Andrew Place

The imposing red-sandstone building overlooking Leith Links was the home of Leith Academy for 125 years. Leith Academy has the longest history of any school in Scotland. It is believed to have been founded in 1560 associated with South Leith Parish Church. Its first recorded premises were Trinity House in 1636, where it was based until 1710. After a disagreement about the £3 a year rent, the school moved to a building which stood on South Leith Parish churchyard. The custom-built premises on St Andrew Place were occupied by the school from 1898 until 1931, when increasing numbers resulted in the building of a new Leith Academy. The St Andrew Place building is now used by Leith Primary School.

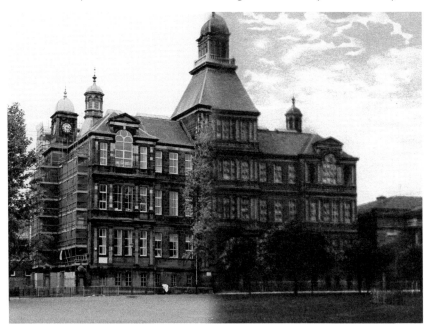

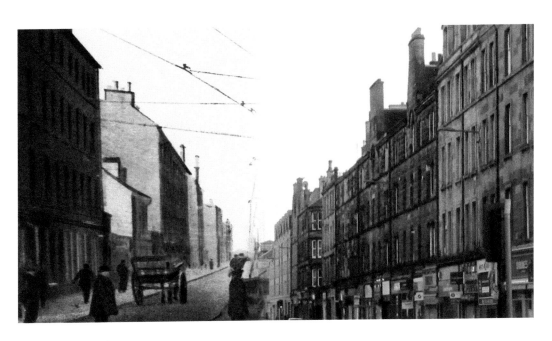

Great Junction Street

Great Junction Street was developed from around 1800 as a link between the Foot of Leith Walk and new docks at North Leith. The idea was to allow a more direct route for heavy goods wagons bound for Leith docks avoiding the congested streets of historic old Leith. It followed the line of the fortifications of 1548, which had left a strip of open ground.

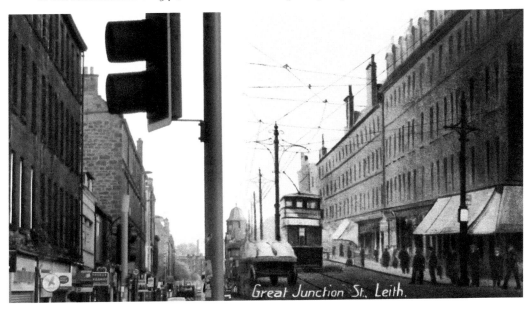

Great Junction St., Leith.

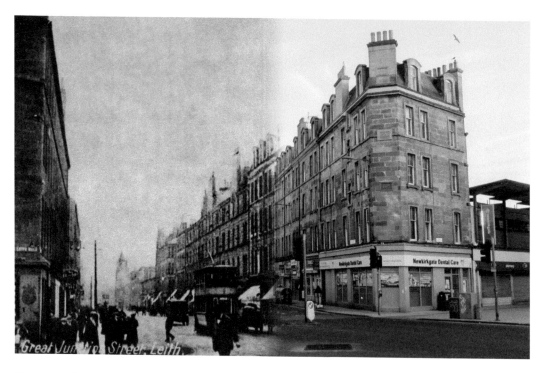

Great Junction Street

Great Junction Street is one of the major routes leading off of the Foot of the Walk. There has been little significant change in the form of the buildings in the 100 years that separate these two images of Great Junction Street.

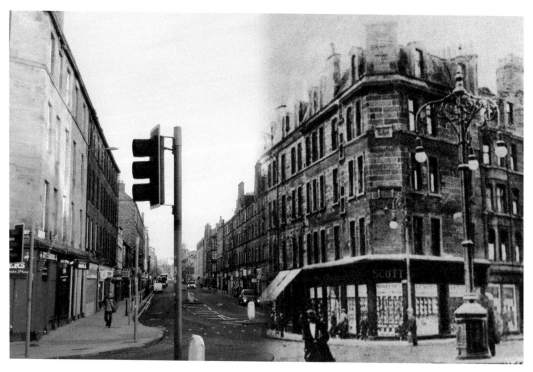

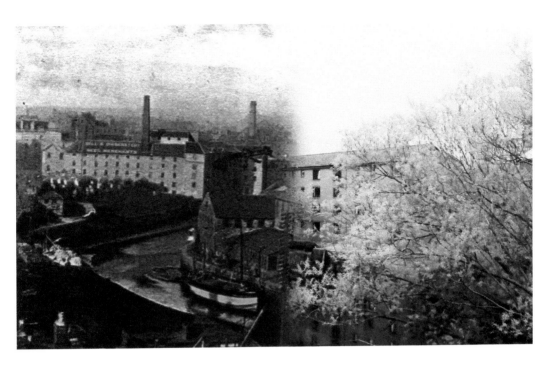

Bird's-eye View of Leith from Ferry Road

A much-changed view of Leith from Junction Bridge. The number of factory chimneys reflects the industrial nature of Leith at the time. Hawthorn's shipbuilding and engineering yard with a moored ship outside is to the right of the Water of Leith in the older image. On the opposite side of the river in the older image it is just possible to see the railway line, the coal sidings near the bridge and North Leith Graveyard.

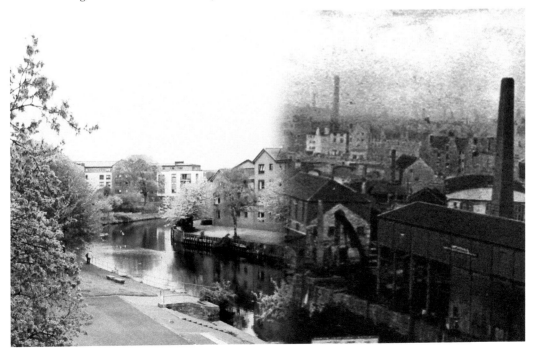

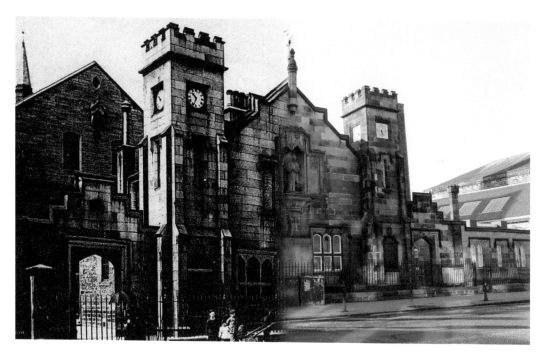

Dr Bell's School, Great Junction Street

Dr Bell's School on Great Junction Street was built in 1839. It was one of two schools founded in Leith by Dr Bell – the other one was on South Fort Street. Dr Bell's School had accommodation for 900 pupils. Dr Andrew Bell (1753–1832) was a minister and an important educationalist who was born in St Andrews. He developed an innovative form of education – the Madras System – during his time in India as a school superintendent. It was based on more advanced pupils helping younger pupils in the school.

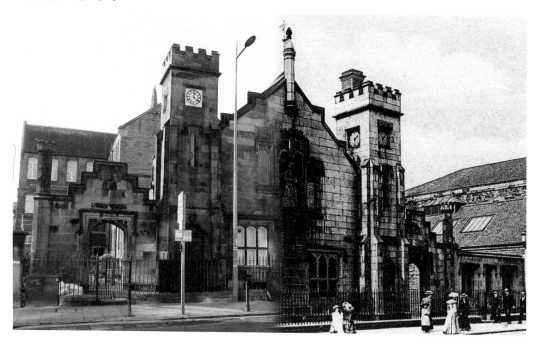

Telectra House, Great Junction Street

The ultra-modern Telectra House appeared on the corner of Great Junction Street and Cables Wynd in 1963 as the flagship store of Leith Provident Co-operative Society. It stood on the site of the earlier St James School. It was demolished in 2003 and the site was redeveloped for flats. (Original image courtesy of Steven Saunders)

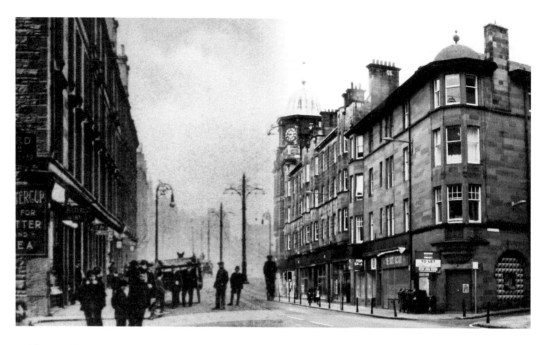

Leith Provident Co-operative Society, Great Junction Street

The turreted building was built in 1911 as a department store for the Leith Provident Co-operative Society. Co-operative societies allowed customers to obtain membership, effectively becoming stakeholders in the company, meaning that the business could be tailored to suit the economic interests of the consumer rather than the store owners. Each customer was assigned their own dividend number, or 'divi', which would see them receive a payment at the end of the financial year based on how much they had spent. The Leith Provident was taken over by the Edinburgh-based St Cuthbert's Co-operative Society in 1966.

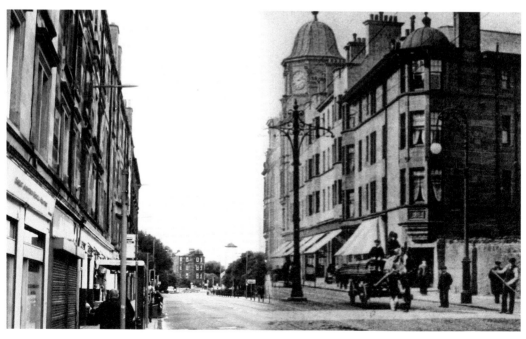

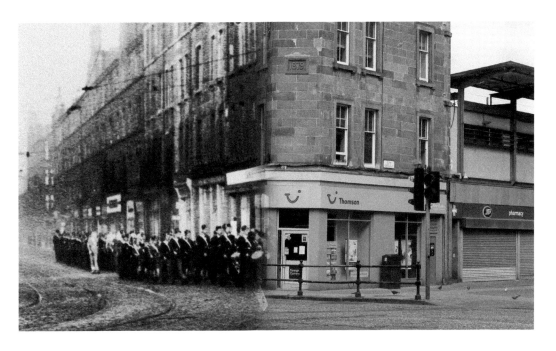

Boys' Brigade Parade, Great Junction Street

Must be a Sunday morning! An atmospheric photograph of the 3rd Leith BB Company on parade heading to the Foot of Leith Walk along a quiet Great Junction Street. The company was based at Claremont Kirk, now Leith St Andrew's, on the corner of Lochend and Easter Road. This company parade is on the occasion of its Golden Jubilee in 1949. (Original image courtesy of Joanne Baird and 3rd Leith BB Archives)

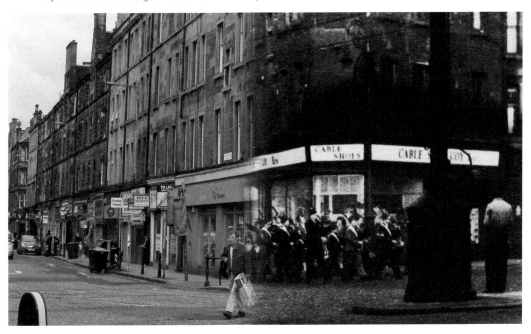

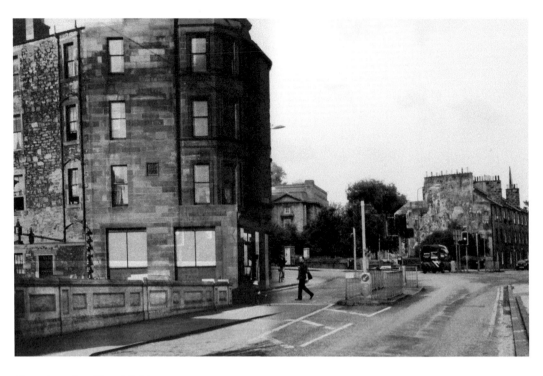

Great Junction Street Bridge
A view across the bridge in 1909 in the older image. The Corner Rooms at the junction with Ferry Road are in the backgorund of the older image. (Original image courtesy of Archie Foley)

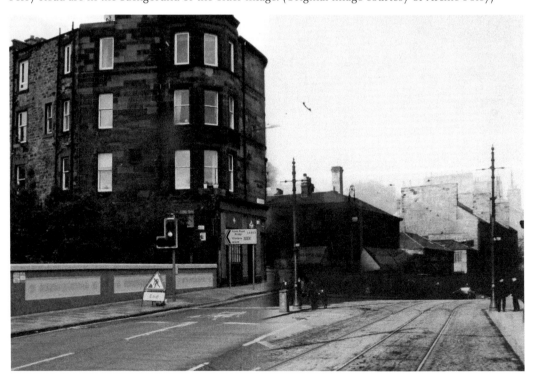

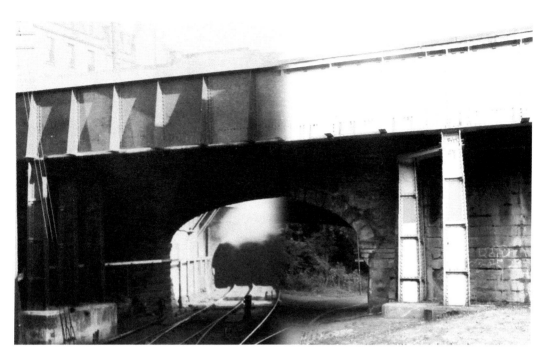

Junction Bridge Station

The older image shows Junction Bridge station in 1909 huddled beneath Great Junction Street bridge. The yawning tunnel ahead eventually led to the Citadel station on Commercial Street. It was the branch line for the Edinburgh, Leith and Newhaven Railway carrying freight and passengers to the Port. (Original image courtesy of Archie Foley)

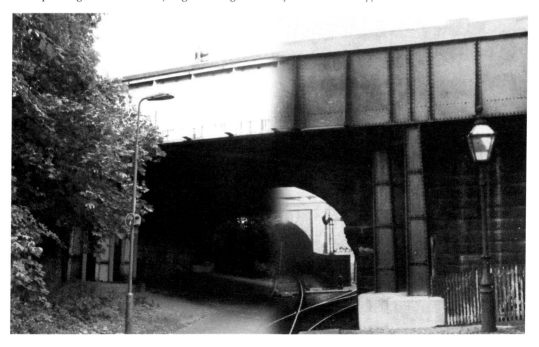

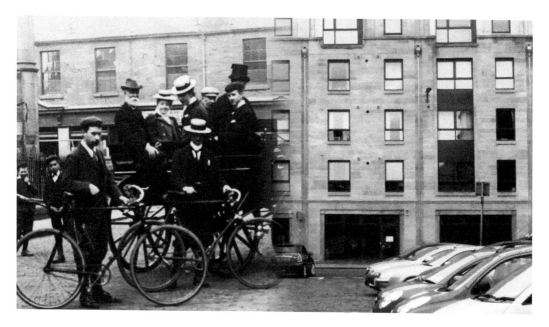

Junction Place

A gathering of well-dressed Leithers, with bikes and a carriage, prepare to set off for a day trip in the older image. Meanwhile, other locals regard the scene with some interest and possibly suspicion on the corner with Great Junction Street. There is a stark contrast between the available transport in the two images.

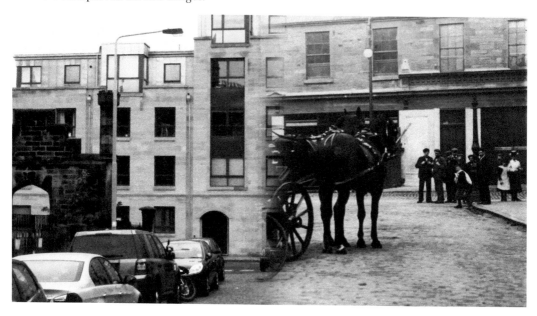

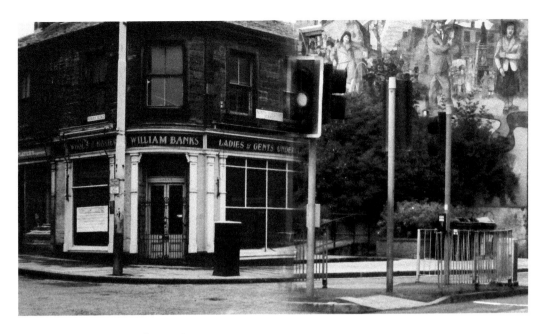

Ferry Road at North Junction Street

The older image shows the buildings on the corner of Ferry Road and North Junction Street next to Leith Library. The upper floor held the Corner Rooms which hosted all sorts of activities from dance classes to pipe band practice. Today, this is an open-air seating area with the Leith Mural on the gable walll. The doorway next to the 'children's wear' sign was the entrance to the Corner Rooms.

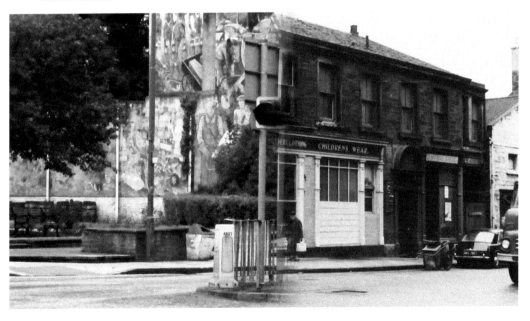

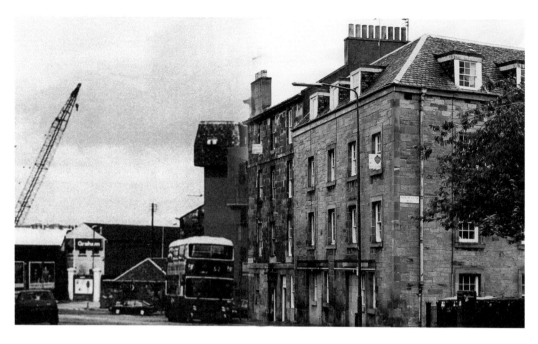

North Junction Street

North Junction Street showing, in the background, the transformation of the harbour area, where more recent housing has replaced the hoists and warehouses of the docks. (Older image courtesy of Steven Saunders)

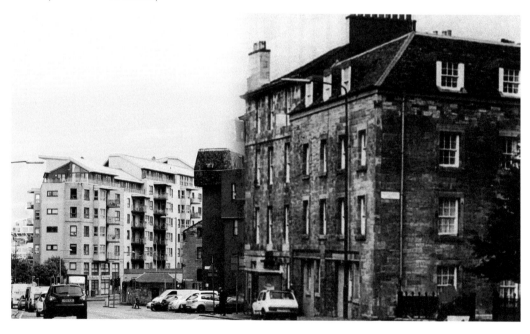

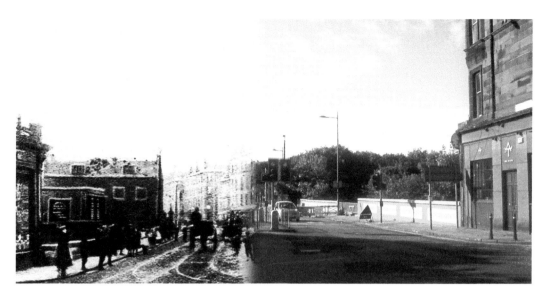

Great Junction Street Bridge
The older image shows a view over the Great Junction Street Bridge in 1904. The station building can be seen on the right-hand side (behind the hoardings) where passengers descended to the platforms below.

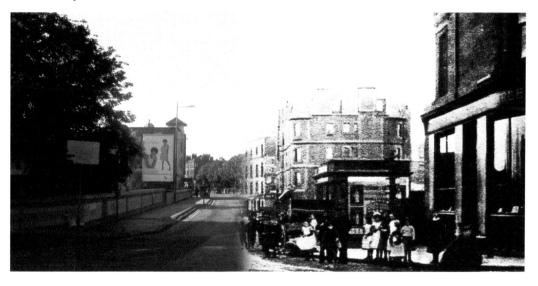

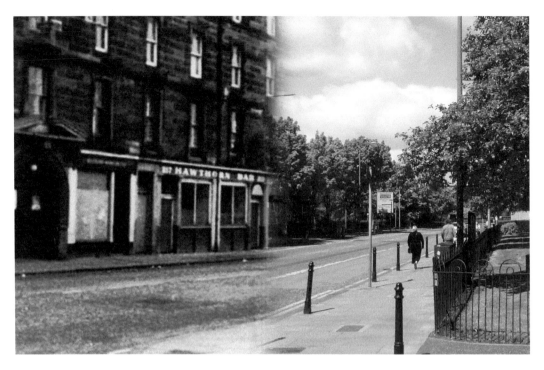

Taylor Gardens

Two of Leith's best-known 'watering holes' – the Hawthorn Bar and Cousin's Bar – were located opposite Taylor Gardens. The tenements were demolished in the 1960s and were replaced by the Quilt's housing area. (Older image courtesy of John Darcy, Old Leithers)

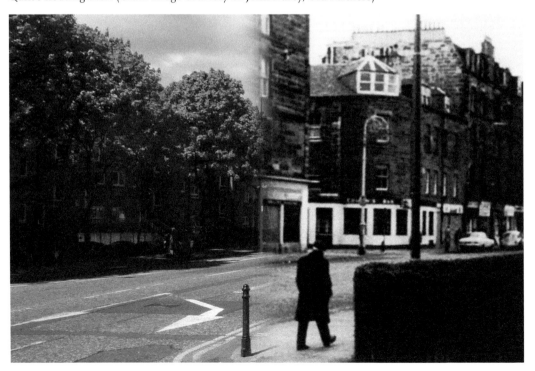

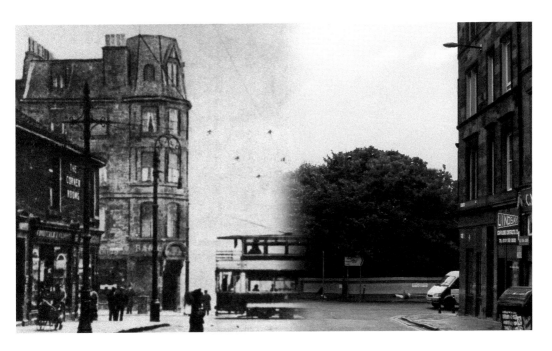

Ferry Road at North Junction Street

The older image shows an electric tram passing on North Junction Street towards Junction Bridge. The Corner Rooms on the left of the older image were the venue for many Leith weddings and other social events.

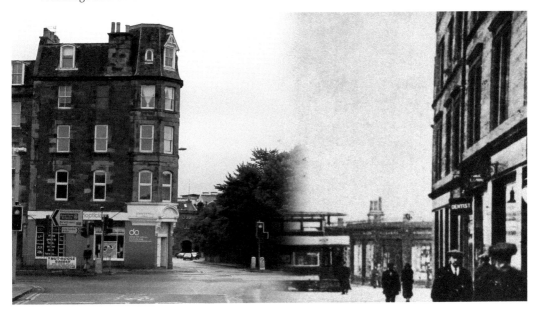

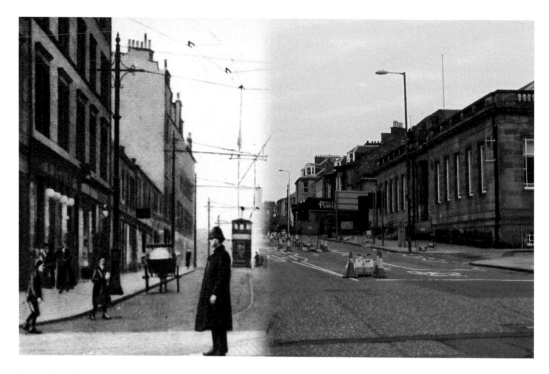

Ferry Road

The older image shows Ferry Road prior to the construction of the library, which dates from 1932. The spire of St Nicholas' Church on Ferry Road (originally the North Leith Free Church, built in 1858) is a feature in the background of the older image – the church was demolished in 1988.

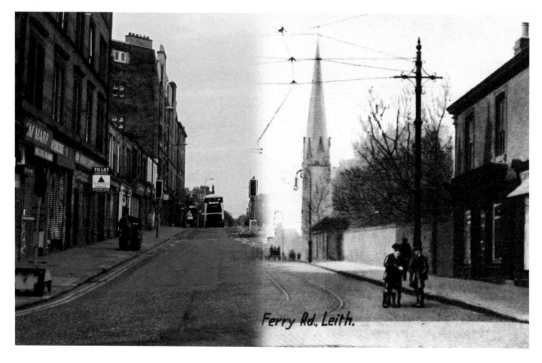

Drambuie, Easter Road

Legend has it that the honey- and herb-flavoured liqueur Drambuie is based on Bonnie Prince Charlie's secret recipe. The first commercial distribution of Drambuie, in Edinburgh, was in 1910. The office and production were based at the foot of Easter Road. The offices were demolished in the mid-1990s. The wall of the old rail bridge crossing Easter Road can be seen just before the new housing in the older image. (Original image courtesy of Steven Saunders)

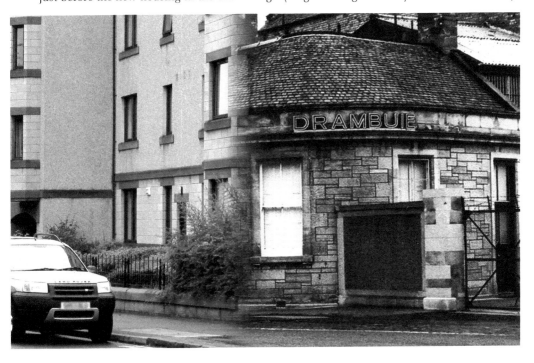

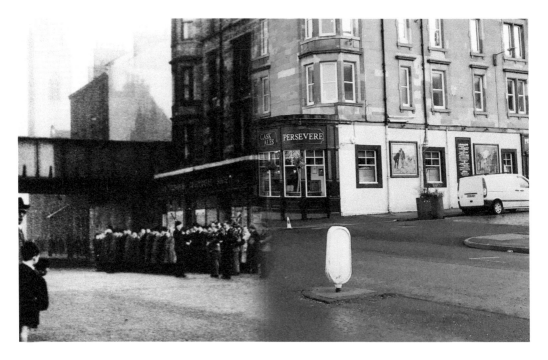

Boys' Brigade Parade, Easter Road

The older image shows the 3rd Leith BB, in 1949, near the foot of Easter Road. Not only are the young lads of the brigade on parade, the 'old boys' also stand to attention outside the Leith Provident Co-operative Society – now the Persevere Bar. The rail bridge to Leith Central can be seen cutting through the tenement building. Today it has been filled with new housing. (Original image courtesy of Joanne Baird and 3rd Leith BB Archives)

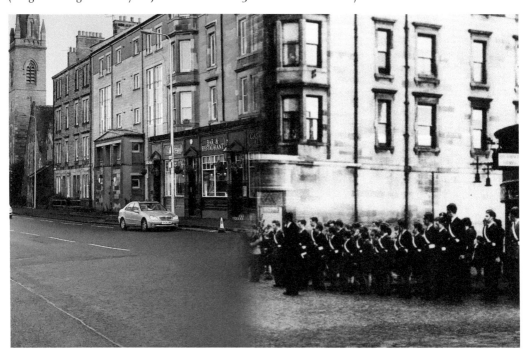

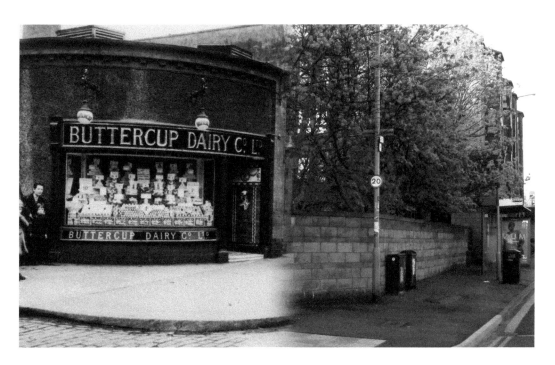

Buttercup Dairy, Easter Road

The Buttercup Dairy Company, founded by Andrew Ewing, established its head quarters in Elbe Street in 1894 and following rapid expansion moved to Easter Road in 1915. It was one of the first chain stores with over 250 shops throughout Scotland. The shops were famous for their beautiful tiled 'girl and cow' murals. (Original image courtesy of Bill Scott www.buttercupdairycompany.co.uk)

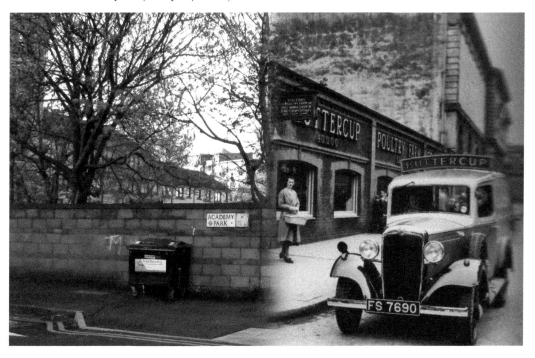

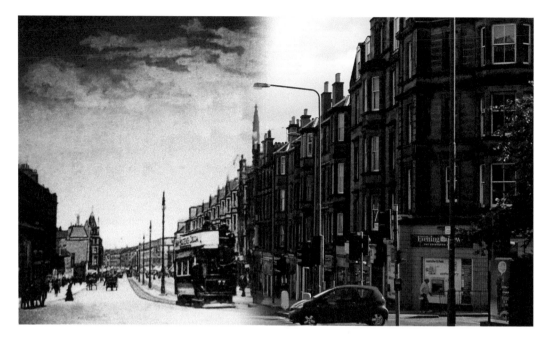

Leith Walk

Leith Walk is now the main route between Edinburgh and Leith. It originated from the defensive earthwork constructed in the mid-seventeenth century to defend the northern approach to Edinburgh against Oliver Cromwell's forces. It developed into a broad footpath for pedestrians only – hence the name Leith Walk. It was established as the main route between Edinburgh and Leith on completion of the North Bridge. In 1799, forty oil lamps were installed, making it one of the first streets in Scotland to have public street lighting.

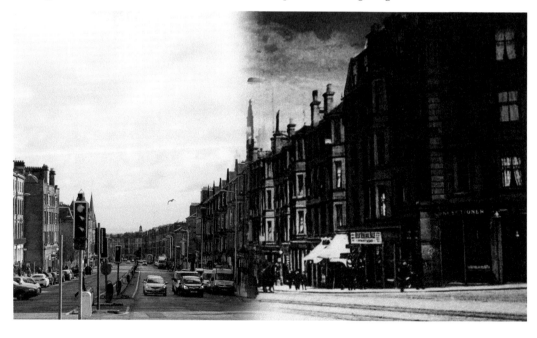

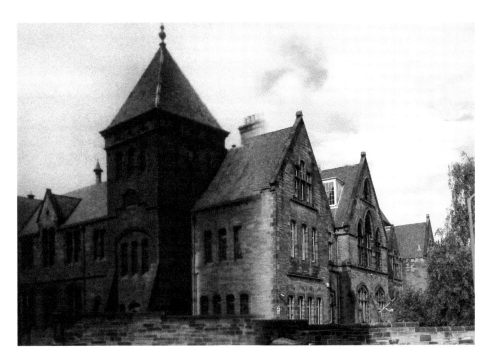

Leith Walk Primary School, Brunswick Road

A large-scale symmetrical Board School, dating from 1875, which was built on the Lovers Loan pathway. The school was one of many built in Scotland, following the passing of the Education Scotland Act of 1872, which followed on from the Elementary Education Act in 1870 in England. The act made education compulsory for children from age five to twelve. A Victorian schoolroom is now located in the grounds of the school.

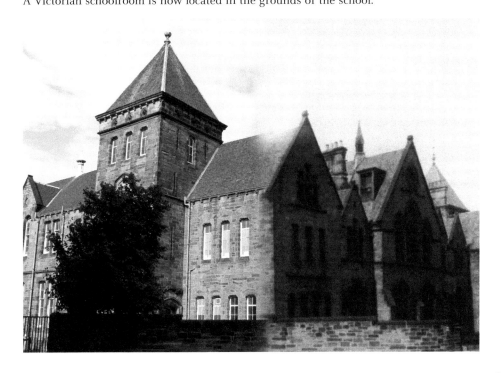

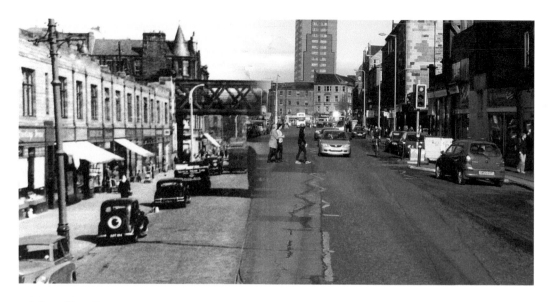

Leith Walk Railway Bridge

The lattice girder bridge over Leith Walk carried the Caledonian Railway Leith Branch. It was removed in September 1980. (Older image courtesy of Bill Robertson)

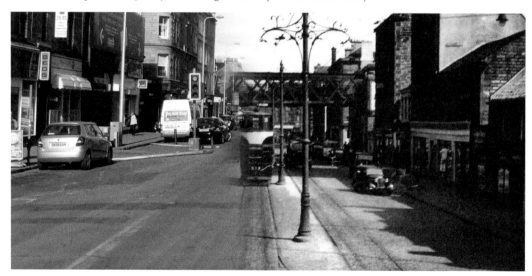

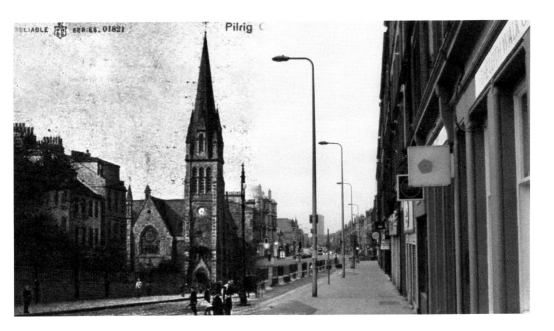

Leith Walk

Pilrig Church is a dominant landmark on Leith Walk and marks the historic boundary between Leith and Edinburgh. In 1905, Leith Corporation Tramways pioneered the use of electric traction. However, Edinburgh's system was predominantly cable-run and passengers travelling either way along Leith Walk were forced to change vehicles at the Pilrig city boundary. The hugely unpopular merger between the two burghs in 1920 formed the catalyst for the upgrade of the Edinburgh network to an electric system. Electric trams finally crossed the frontier on 20 June 1922 and the chaotic interchange known as the 'Pilrig muddle' was eradicated.

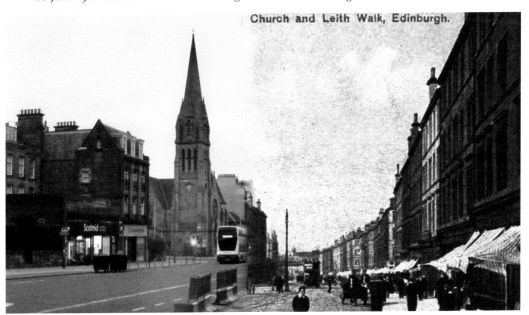

Church and Leith Walk, Edinburgh.

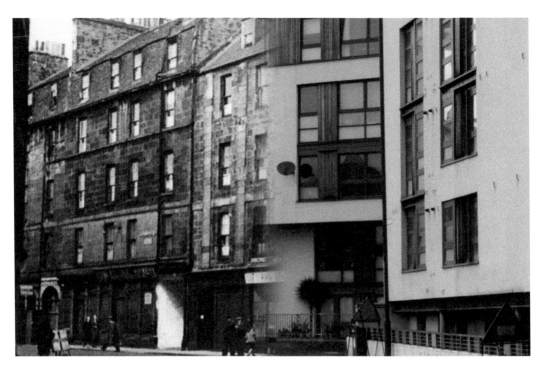

Bridge Street

Bridge Street was one of the main arteries of North Leith leading to the Upper Drawbridge. It was a densely populated tenement area which was fondly remembered for its sense of community. The newer image shows the new housing on the corner of Sandport Street.

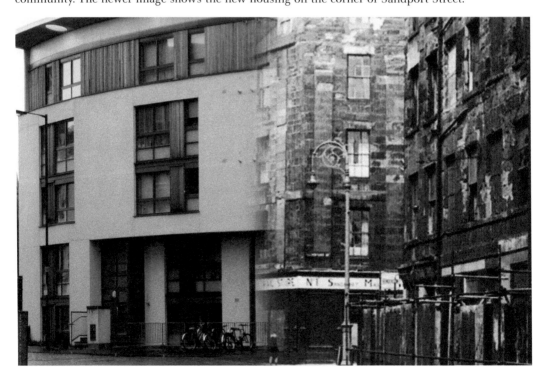

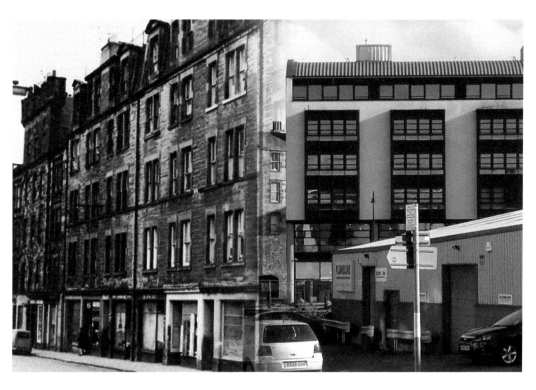

Bridge Street

These images of Bridge Street looking towards the Water of Leith show the radical change in the character of the area.

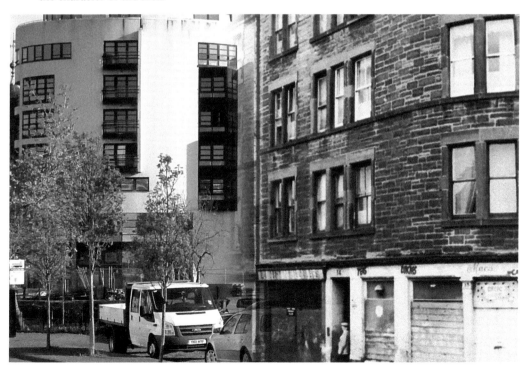

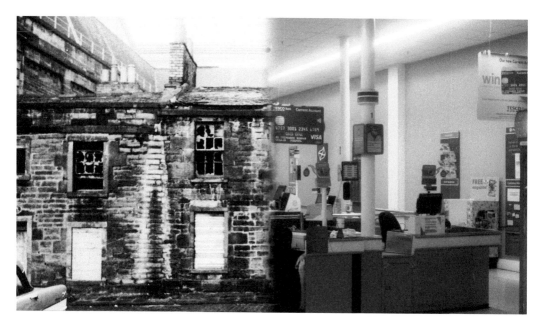

Glover Street

Glover Street ran from Manderston Street directly through to Duke Street. That was until Leith Central station was built in 1898, at which point the street was cut in two by the huge station leaving a small stump off Duke Street. Today supermarket tills mark the line where the street ran.

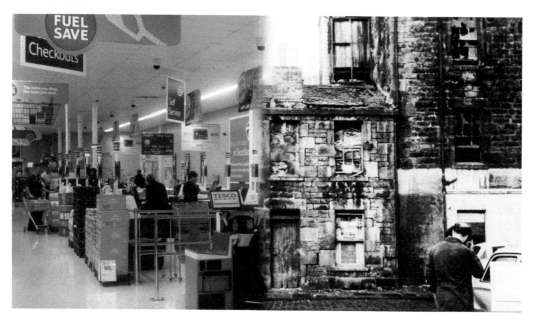

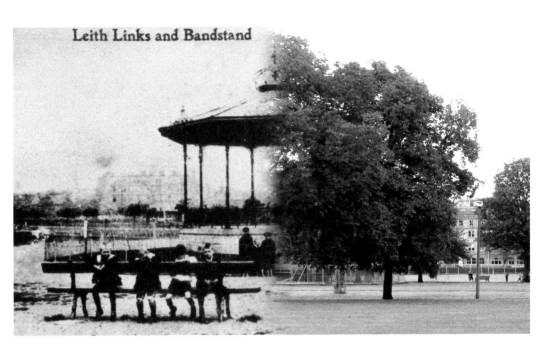

Leith Links and Bandstand

Leith Links

Leith Links were part of a larger area of common land which stretched along the coast including part of Seafield. Links is Scots meaning sandy ground with hillocks and dunes, and the present artificial flatness dates from around 1880 when they were remodelled into a formal park. These improvements removed most of the world's oldest golf course, which is mentioned as early as 1456 when King James II imposed a ban on the game because it disrupted archery practice on the Links. The first Rules of Golf, which are the basis of the modern game, were drawn up in 1744 for use on the Links by Leith's Honourable Company of Edinburgh Golfers.

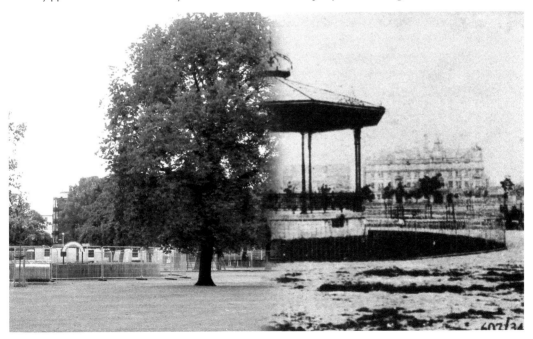

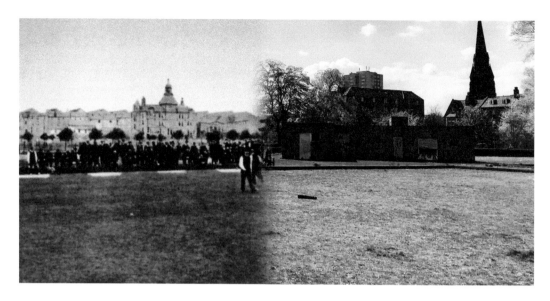

Leith Links

A crowd of spectators look on as a bowling competition is in progress on Leith Links. The steeple of St James's Episcopal Church is in the right background. The former Leith Academy building can also be seen in the background. The building is now Leith Primary School. In the contemporary view the trees on Leith Links practically obscure the school. Some of these trees were planted to commemorate Queen Elizabeth's coronation in 1953.

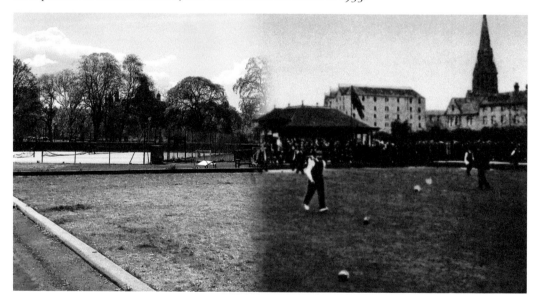

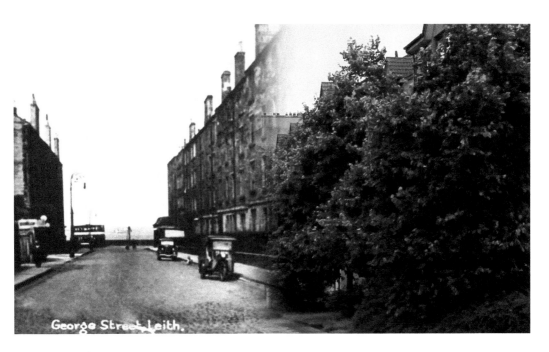

George Street

George Street in Leith was laid out around 1812 and was named for George IV. In 1966, to avoid confusion with George Street in Edinburgh, it was renamed North Fort Street. In the older image a tram is travelling on Lindsay Road. The view of the sea at the end of the street in the older image is now blocked by the Chancelot Mill. (Older image courtesy of Joanne, Old Leithers)

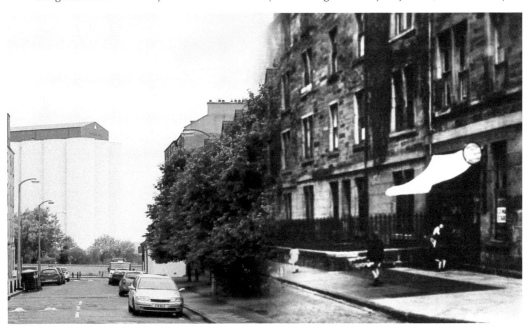

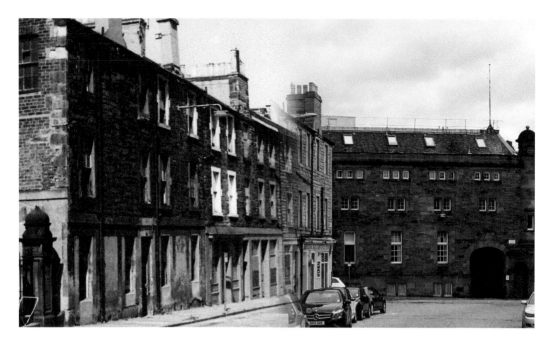

Coburg/Couper Street

The older image shows the frontage of the headquarters and warehouse of Melrose's Ltd tea and coffee merchants at 55–57 Couper Street. Melrose's was a popular brand and they had a number of shops in the Edinburgh area. Andrew Melrose established the company in 1812 and when the tea clipper *Isabella* landed a consignment of tea at Leith in 1835, Melrose became the first tea merchant to import tea into Britain, outside of London. The warehouse, which dates from around 1900, has been converted into flats.

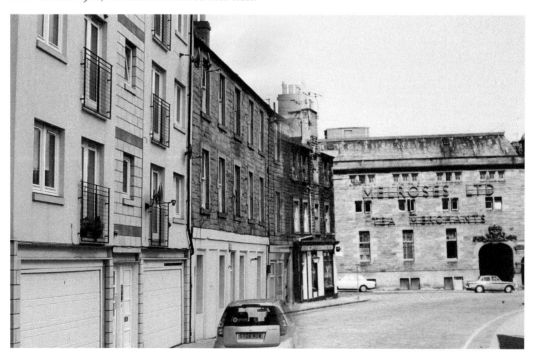

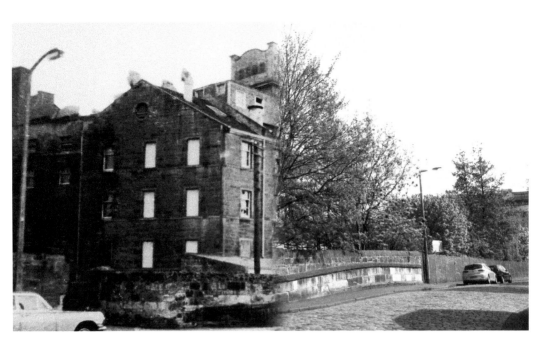

South Fort Street

The older image shows the Scottish Co-operative Wholesale Society grain mill not long before its demolition in the 1960s. The small arched wall in the foreground is the parapet from the bridge crossing over the rail line that ran onto the Citadel station (North Leith). Today this railway line is one of Leith's many cycle/walkways.

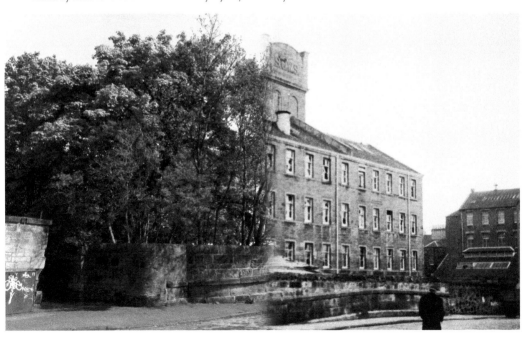

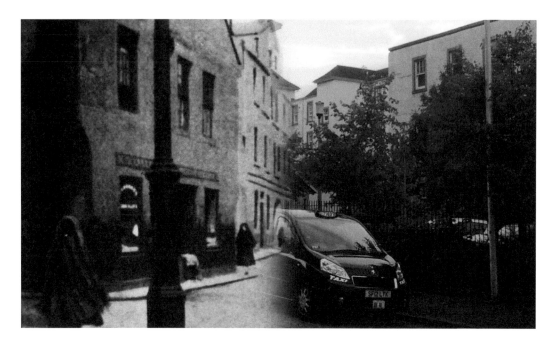

Meeting House Green

Meeting House Green took its name from a building in which dissenting Presbyterians worshiped in the late seventeenth century. It was also the site of Leith Soap Works, which were opened in 1619 by a Nathaniel Uddart. Uddart was granted the monopoly of soap making in Scotland for twenty-one years, on payment of an annual £20 duty to the Crown. He erected a 'goodly work' in Leith for the purpose. However, it does not seem to have been a prosperous undertaking – not so many people were given to regular washing at the time. Meeting House Green is long lost under the foundations of modern housing between the modern-day Cables Wynd and King Street.

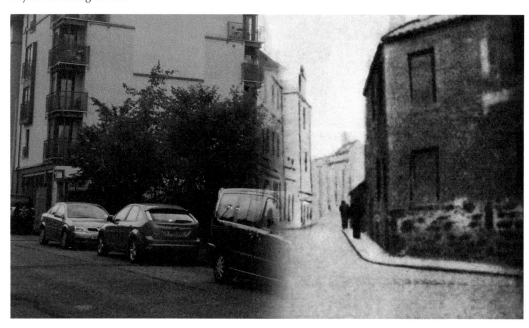

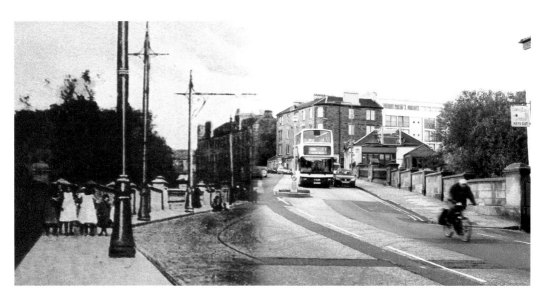

Bonnington Bridge

A tram crosses Bonnington Bridge in the older image. The current Bonnington Bridge dates from 1902 to 1903 and replaced an earlier bridge which dated from 1812.

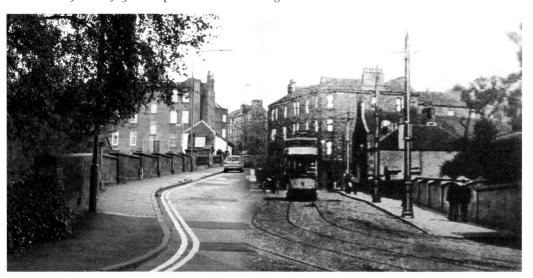

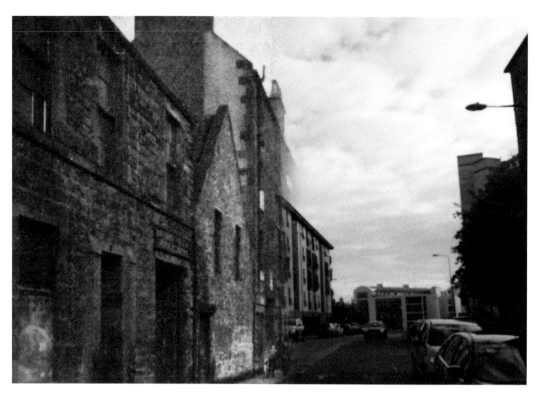

Cables Wynd

Cables Wynd was named after Henry Capell, a former veteran of Oliver Cromwell's army, who set up business in Leith as a maltman and brewer in the mid-1600s.

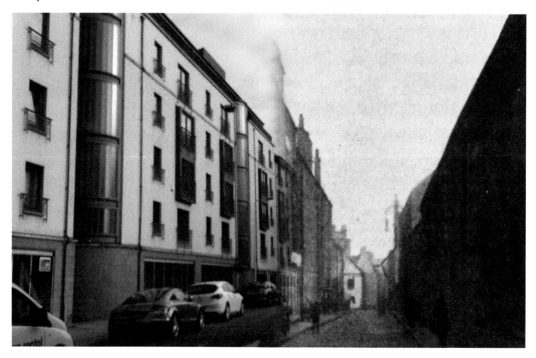

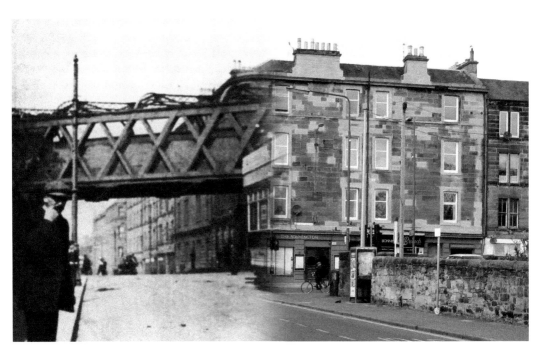

Bonnington Toll

Bonnington Toll is an important junction where roads from Canonmills, Newhaven, Leith and Leith Walk converge. In the older image a state-of-the-art Leith Corporation electric tram is making its way up Pilrig Street towards Leith Walk. In the background is the Caledonian Railway girder bridge dominating this junction, as it runs diagonally over the crossroads. The bridge was demolished in 1968.

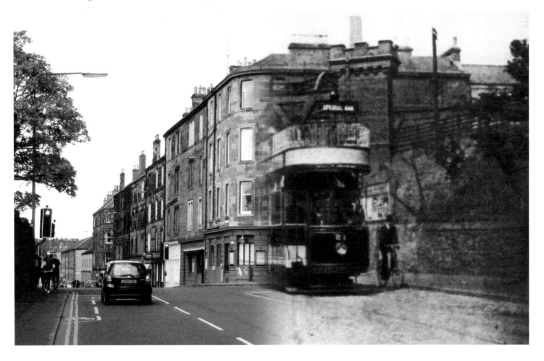

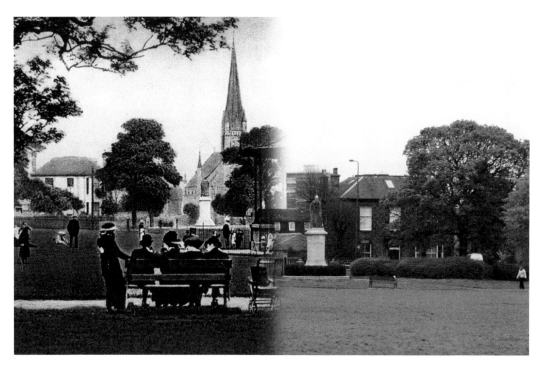

Victoria Park

Victoria Park was known as Raimes Park before its name change in 1919 in honour of Queen Victoria. The statue of King Edward VII was erected in 1913. The bandstand in the older image is long gone.

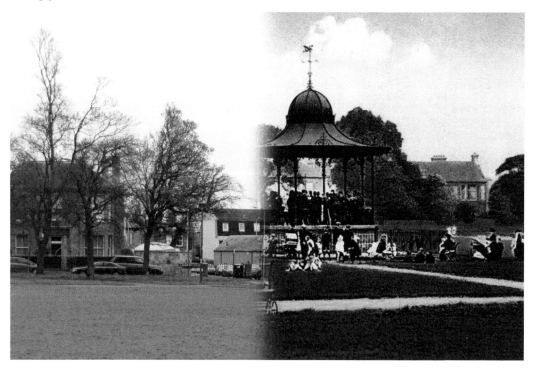

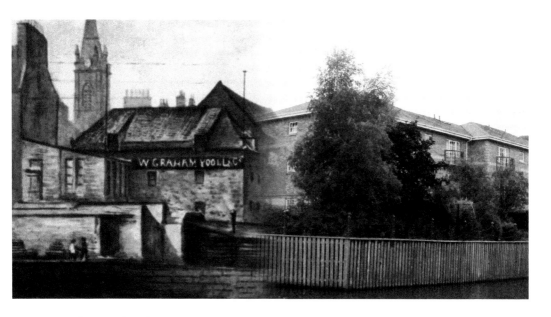

W. Graham-Yool and Company

W. Graham-Yool and Company's pier and warehouse were at the lower end of Sheriff Brae adjoining where the east abutment of the old Brig o' Leith was located. W. Graham-Yool and Company had many business interests in Leith and well beyond.

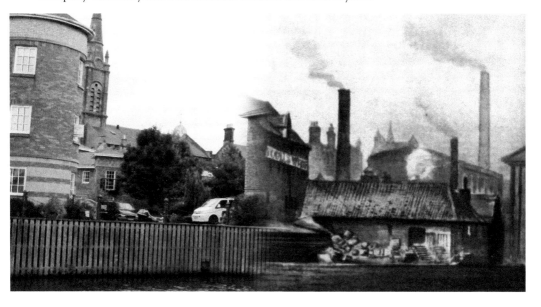

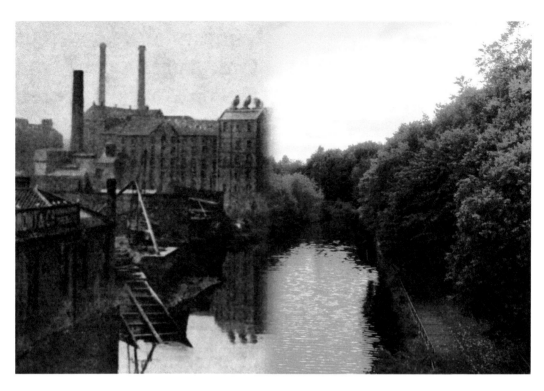

Junction Mills
The industrial complex of Junction Mills, close by the Water of Leith, have long disappeared and been replaced by a greener landscape.

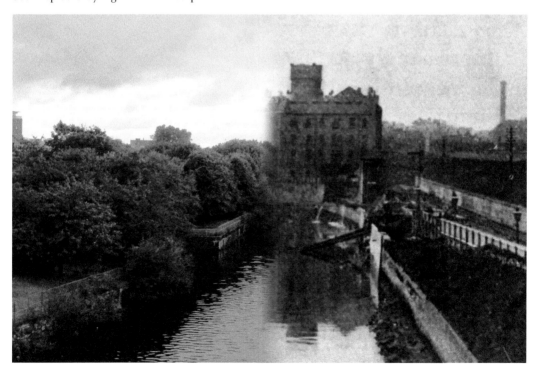

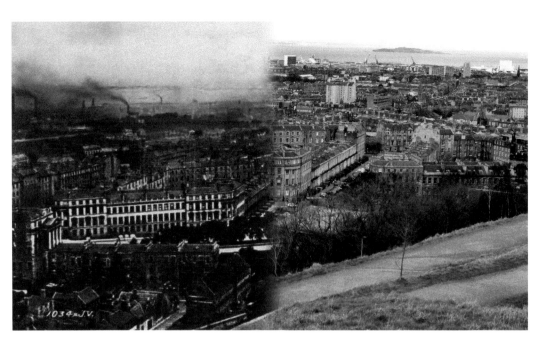

Leith from Calton Hill
A spectacular contrast between the old industrial Leith and the modern town in this view from Calton Hill.

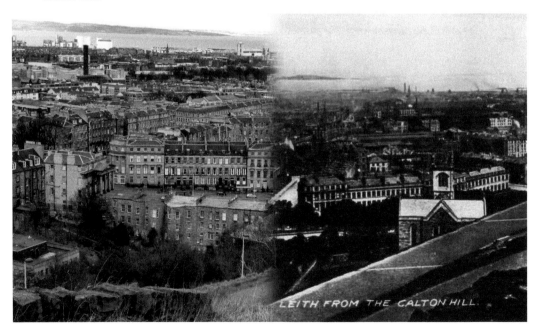

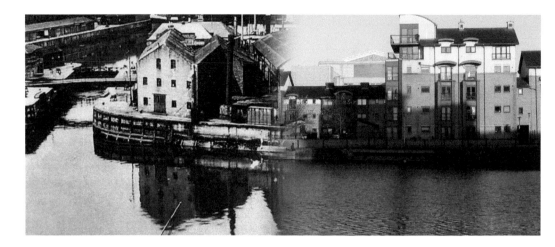

Leith Harbour

The original harbour at Leith was a quay at the mouth of the Water of Leith. This was upgraded by the East and West Old Docks in the early nineteenth century. The Victoria Dock followed in 1847–51, the Prince of Wales Graving Dock was added in 1858 and the Albert Dock, which was the first in Scotland with hydraulic cranes, was completed in 1869. The Edinburgh Dock was built for coal delivery in 1877–81, and the final wet dock, the Imperial Dock, was completed in 1896–8. A second large graving dock, the Alexandra, was added beside the Prince of Wales Dock in 1896. The Forth Ports Authority was established in 1968 to control the ports on the Forth with their headquarters at Leith.

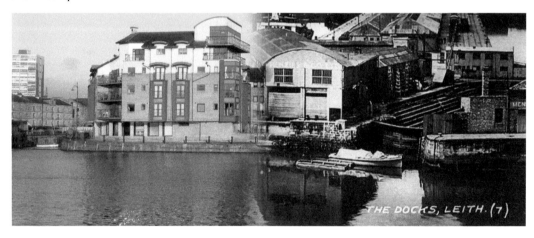

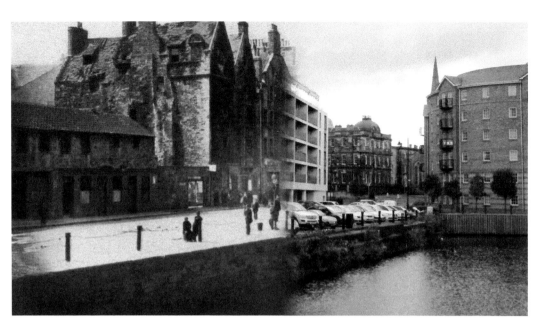

Mary of Guise's House, Coalhill

In 1548, during the civil war between Mary of Guise and the Scottish Protestant lords, the Queen Regent moved the seat of government to Leith, built fortifications, and held the town for twelve years with support from France. The fortifications ran from the west end of Bernard Street south-east to the junction of the present Maritime Street and Constitution Street, south to the foot of Leith Walk, returning to the Shore along the line of what is now Great Junction Street. Mary of Guise died In June 1560, and the Siege of Leith ended with the departure of the French troops. There is some debate about the location of Mary of Guise's residence in Leith which is normally given as being in Water Street (Rotten Row) and this old postcard is possibly erroneous in its description.

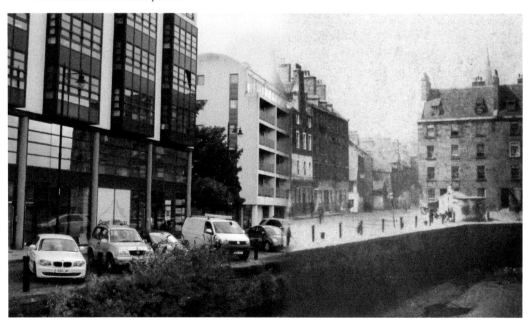

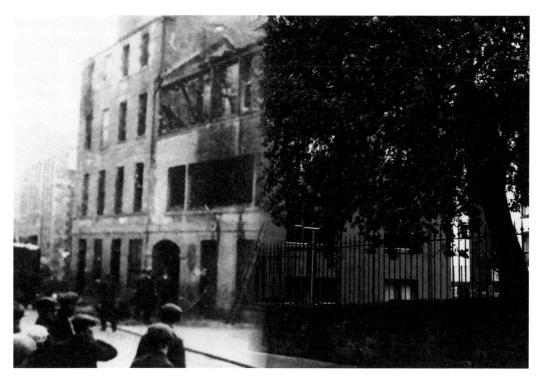

Coburg Street

This is a scene of a fire at David Bell's in Coburg Street. The graveyard of North Leith can be seen on the right side of the shot.

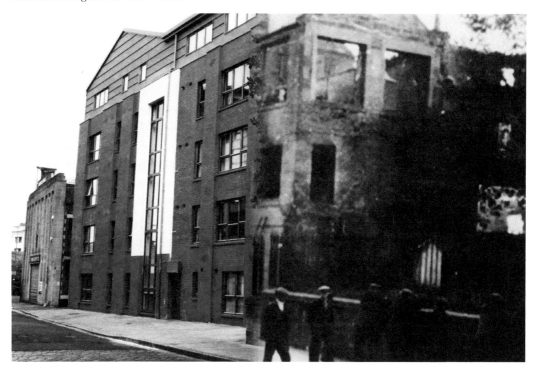

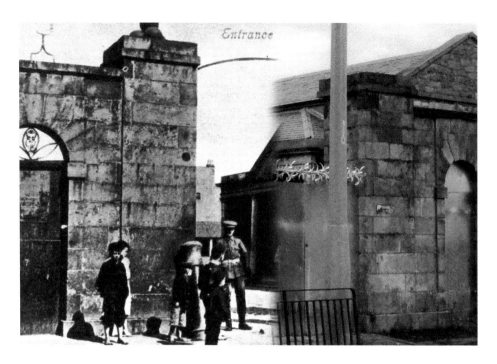

Leith Fort

A group of soldiers and some Leith kids gather at the gate of Leith Fort in the older image. Leith Fort was built in the 1780s following an attack on the port by a flotilla of American ships in 1779. In the 1950s, the fort buildings were demolished for the construction of the Fort House flats. In 2013, Fort House was itself demolished to make way for a new housing development.

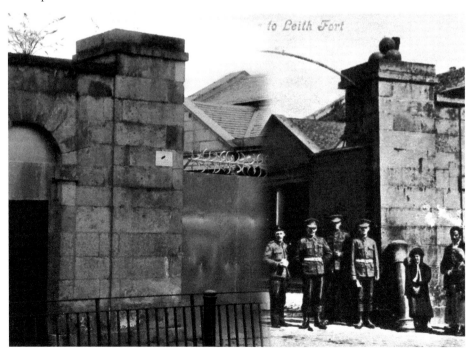

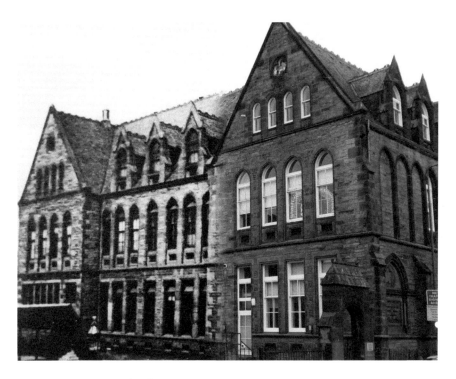

Former Lochend Road School
The foundation stone of the former Lochend Road School was laid on 17 October 1885 and the school opened on 29 January 1887. An inscribed stone plaque showing a three-masted sailing ship and the Leith motto *Persevere* celebrate the school's association with maritime Leith.

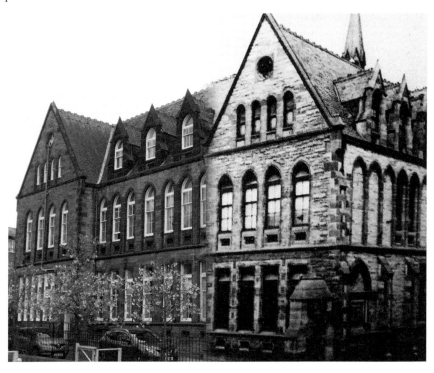

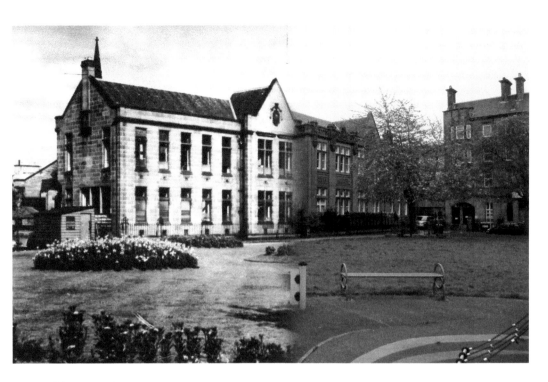

Leith Hospital

Leith Hospital opened in 1851. It was dependent for funding on donations and legacies, until it was taken over by the NHS in 1948. The Leith Hospital Pageant was first established in 1907 to raise funds for the ever-expanding hospital. It was an immensely popular annual event that raised thousands of pounds to support the hospital. Leith Hospital was closed in 1987 and the building was converted into flats.

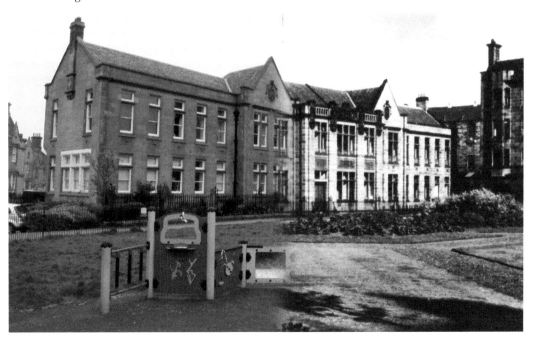

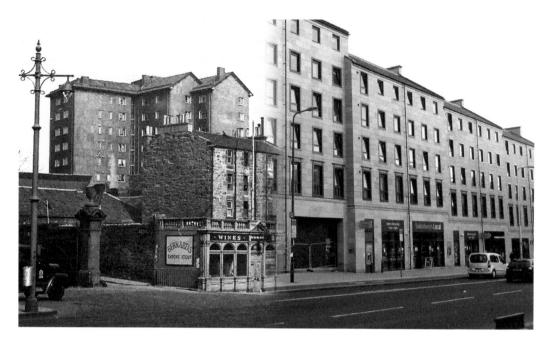

Shrubhill

These images reflect the considerable redevelopment at Shrub Hill. Shrub Hill was the site of the Gallow Lee, the place of the public execution of alleged witches, Covenanters and others that had been found guilty of major crimes. Some were left hanging in chains for years. The unfortunate victims were cremated on the spot – the ashes from centuries of executions were eventually carted away and converted into mortar for the construction of New Town buildings.

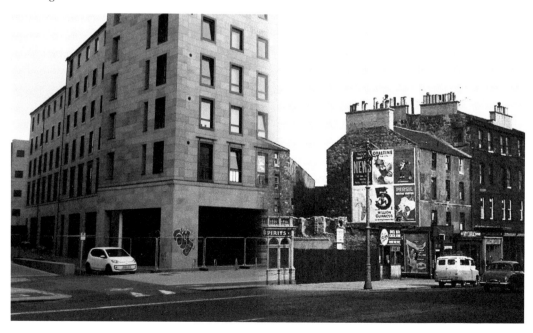

Acknowledgements

We would like to thank a number of people for their help with the book.

Huge thanks to all those who contributed images: Archie Foley, Joanne Baird, Steven Saunders, Bill Robertson, Jennifer Wells, Doreen McTernan and Bill Scott.

The friends of the Spirit of Leithers (www.facebook.com/pages/The-Spirit-of-Leithers) and Lost Edinburgh (www.facebook.com/lostedinburgh) Facebook pages are a regular source of inspiration. Particular thanks to the following Spirit of Leithers: Frank Ferri, John Dickson and the other hundreds of regular contributors.

Special thanks to Julie Dewar for their help with images.

Last, but not least, Emma Jane and Yvonne, our patient and long-suffering wives.

Jack and Fraser